IMAGES
of America

BRAINTREE

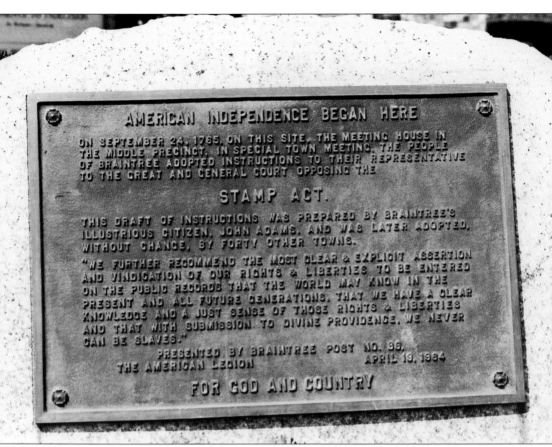

The Stamp Act monument, located steps from First Congregational Church on Elm Street in Braintree, accurately declares, "American Independence Began Here." In 1765, the Braintree Town Meeting declared its opposition to the Stamp Act: "We further recommend the most clear & explicit assertion and vindication of our rights & liberties to be entered on the public records that the world may know in the present and all future generations, that we have a clear knowledge and a just sense of those rights & liberties and that with submission to divine providence, we never can be slaves." (Courtesy of the Braintree Historical Society.)

ON THE COVER: This view of South Braintree Square, looking east, was taken at the beginning of the 20th century. While Hobart's store on the left and the Tracey building on the right no longer exist, the two buildings in the center of the picture are still there. (Courtesy of the Braintree Historical Society.)

IMAGES
of America

BRAINTREE

John A. Dennehy

ARCADIA
PUBLISHING

Published by Arcadia Publishing
Charleston SC, Chicago IL, Portsmouth NH, San Francisco CA

Printed in the United States of America

Library of Congress Control Number: 2009935597

For all general information contact Arcadia Publishing at:
Telephone 843-853-2070
Fax 843-853-0044
E-mail sales@arcadiapublishing.com
For customer service and orders:
Toll-Free 1-888-313-2665

Visit us on the Internet at www.arcadiapublishing.com

Trish, Erin, Shannon, and Jackie

CONTENTS

ACKNOWLEDGMENTS

I wish to thank the Braintree Historical Society for the wonderful job they do preserving Braintree history and for making its tremendous photograph collection available to me. Unless otherwise noted, all images appear courtesy of the Braintree Historical Society. I would also like to acknowledge the contributions of H. Hobart Holly, Gilbert Bean, and Otis B. Oakman Jr. to Braintree history. Their love of history and Braintree was evident in their work, and the written materials they prepared over many years were an invaluable resource to me. I am also grateful to Mayor Joseph C. Sullivan, Paul Carr (president of the Braintree Historical Society), Nancy Nicosia, Marjorie Maxham, Richard Grey, Carl R. Johnson III, Bob DiTullio, Mark Cusack, Ann Toland, Archie Green, Brian Adams, Steve Kenney (Massachusetts Archives), and Kimberly Reynolds (Boston Public Library) for their kind assistance in securing specific photographs. Most importantly, I would like to thank my family. My three beautiful daughters, Erin, Shannon, and Jaclyn, were tremendously helpful to me as I worked on this book and were very patient when their dad was not always available to go for a hike. Last, but not least, I would like to thank my bride, Patricia, who has supported my passion for history since the day we met and who encouraged me in this project even as our house was filled with hundreds of dusty old photographs and books.

INTRODUCTION

The town of Braintree was incorporated in 1640 and originally encompassed what are now the towns of Braintree, Quincy, Randolph, and Holbrook. The earliest concentration of homes in old Braintree's Middle Precinct were built near one of the first ironworks in America on the Monatiquot River in the area of what are today Elm, Adams, and Middle Streets. Soon after the small settlement extended west down Elm Street, a meetinghouse was built in 1705 at the approximate spot where the First Congregational Church now stands. The building, located in what was called Thayer's Corner, soon became the home of old Braintree's Second Parish Church. The intersection was later referred to as Storrs Square or Braintree Square. Within a few years, another small settlement emerged in and around what is now referred to as South Braintree Square. Meanwhile, on the eastern edge of Braintree's Middle Precinct, a small maritime community grew near the banks of the Fore River and Smelt Brook.

Old Braintree was the birthplace of several prominent Americans, including John Adams, John Hancock, John Quincy Adams, and Gen. Sylvanus Thayer, the "Father of West Point." In 1765, the Town of Braintree issued the first formal challenge to British Parliamentary authority in America when the Braintree Town Meeting passed the Braintree Instructions, a powerful and eloquent protest of the Stamp Act. The instructions were quickly adopted by dozens of Massachusetts communities and contributed significantly to the repeal of the hated tax initiative. Although the actual meetinghouse and church where this historic vote had taken place is no longer there, visitors to Braintree can view the Stamp Act monument on the grounds of First Church.

With the arrival of the railroad in 1845, Braintree began to emerge as an industrial center, even as it retained its rural character. The town became home to several mills and manufacturing plants, including several shoe factories clustered around the South Braintree railroad station. With the benefit of train service, workers from throughout the region were able to commute to Braintree at little cost, and factory owners were able to transport their goods cheaply and efficiently. Hotels were also built within a few hundred yards of the two main railroad stations to accommodate the growing number of people visiting the town. Similar changes were also taking place in East Braintree, a community that had evolved around the maritime industry. Thomas Watson's Fore River Engine Company on the Fore River joined a growing number of businesses along the coastline, making the neighborhood around Quincy Avenue and Weymouth Landing a thriving center of activity. In this age of improved transportation, Braintree's proximity to Boston ensured that the town remained busy and prosperous.

This book is not a history of Braintree. It is instead a celebration of a time in Braintree history that is often overlooked and little understood. Therefore, with few exceptions, the photographs in this book portray life in Braintree as it was between 1870 and 1960, with particular emphasis on the period between 1890 and 1920. It is hoped the readers will get an idea as to what the town

looked like and how people lived at the beginning of the 20th century. Even with the influx of people and materials into Braintree during this period, these pictures suggest that life in the town remained remarkably peaceful and simple.

While readers will be able to identify several landmarks, they will be surprised (or perhaps not) at how much the town has changed. Although the tranquil scenes of the 1890s may no longer exist, Braintree continues to attract people and businesses from throughout the region. It was not possible to include all available photographs. Needless to say, the faces contained in chapter 9 represent just a small cross section of people who contributed to the life of Braintree. There are likely many more images that could have been used. Braintree is my hometown, and I have enjoyed pulling together old photographs of the streets I have walked for almost 48 years. I hope you enjoy them as much as I do.

One

TOWN HUBS

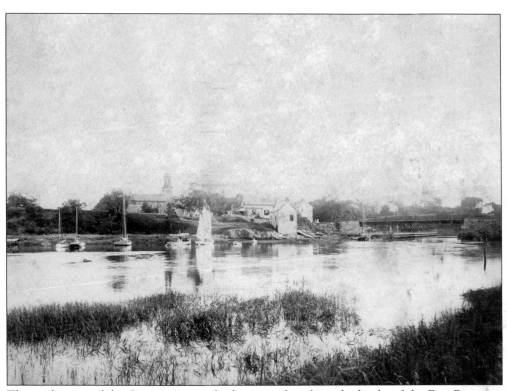

This early view of the Quincy Avenue bridge was taken from the banks of the East Braintree shore (now Watson Park), facing west. Likely taken in the early 1880s before the arrival of Thomas Watson, it captures the Union Church with its prominent tower in the distance. With its rolling hills and access to the sea, East Braintree still offers the best and most striking views in town.

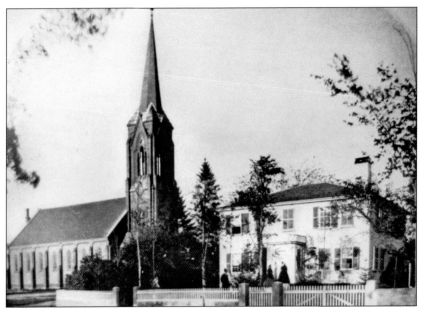

The above photograph of First Congregational Church and the home of Rev. Richard Salter Storrs must have been taken before 1869 because the original tower and spire (seen here) blew down in that year. Storrs was pastor of First Congregational Church from 1811 to 1873. The photograph below of Storrs Square was likely taken between 1875 and 1885. "Dr. Storr's Church," which dominates the center of both pictures, was the fourth church and meetinghouse to be constructed on this site. Built in 1857, this church was destroyed by fire in 1912. The fire that consumed the landmark started in the lyceum building, seen below at left. The lyceum housed two businesses on the lower level and a large hall upstairs, which served as a center for town activity for decades. The Ebenezer Thayer house can be seen in the distance to the right. Thayer, who was born in that house in 1746, was an influential town leader during the American Revolution. The house was demolished in 1896. The granite trough seen next to the water pump below in the left foreground dates back to the 1860s and currently resides at the Braintree Historical Society.

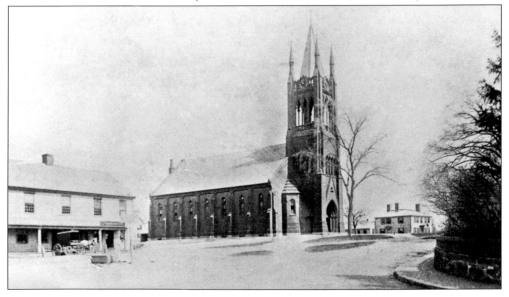

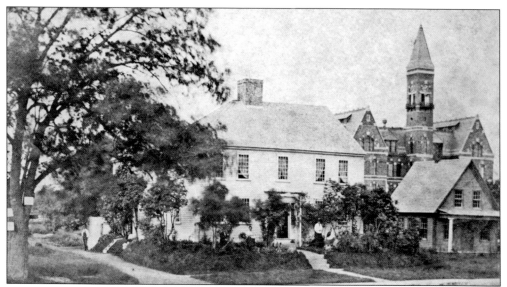

A landmark in the heart of Braintree's town center for more than 100 years, the Arnold Inn and Tavern, built in 1800, was located on the northern corner of Washington Street and Central Avenue. So central was the tavern to town affairs that the first town house (town hall) was built directly across the street at the top of what is now Union Street. This picture was taken between 1880 and 1885 and shows the tavern's close proximity to Thayer Academy.

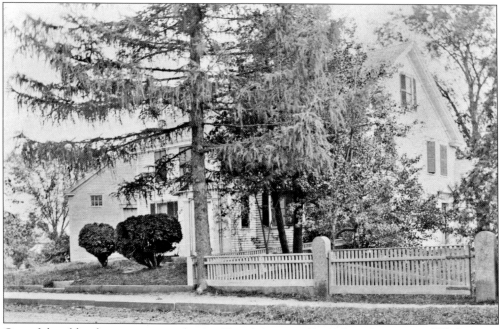

One of the oldest houses in town, the Asa French house still stands at the corner of Washington Street and Union Place. The town center grew around this private home, which also served as the town's first post office in the 1840s. After the 1858 town hall was destroyed by fire in 1911, town business was conducted in the French house until the new (current) town hall was completed in June 1913. This picture was taken in 1892 when the large barn still stood on the northerly side of the house. The central fire station currently occupies the ground on which the barn stood.

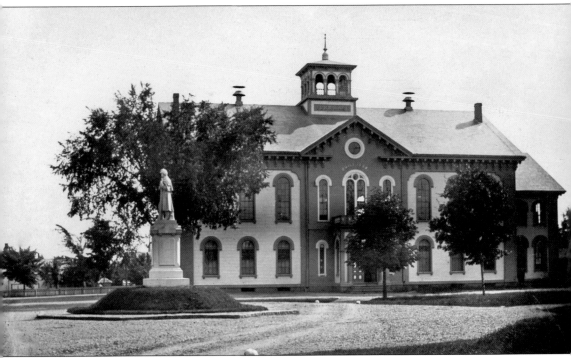

The Braintree Town House (town hall) was built on the northerly corner of French's Common on Washington Street in 1858, replacing a smaller 1829 structure located across the street from the Arnold Inn and Tavern. This building was dedicated by Charles Francis Adams, the son and grandson of Braintree natives John Quincy Adams and John Adams, respectively. This north side view of the town hall was taken before 1910. French's Common can be seen in the distance to the left, while the Civil War monument dominates the foreground. The monument was dedicated on June 17, 1874, and was later moved several yards closer to Washington Street on the town hall mall to accommodate more parking on the north side of the town hall.

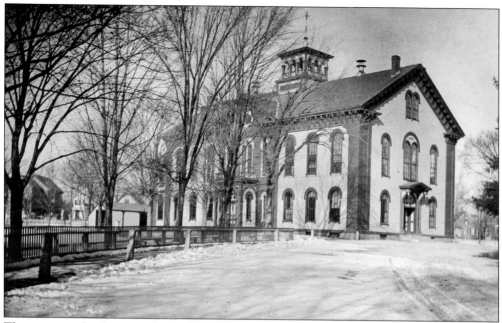

These two south side views of town hall were likely taken between 1895 and 1910. This beautiful and spacious wooden structure contained not only town offices and a large hall on the second floor, but also housed the town's first high school on the first floor until 1892. The above picture was taken after a winter snow, as evidenced by the photographer's footprints at lower left. While the wooden fence has long since been replaced by chain link and the hitching posts replaced by yellow-lined parking spaces, the scene as one approaches town hall from the south is remarkably familiar to current-day residents. The below picture of the southern side of old town hall was taken from French's Common.

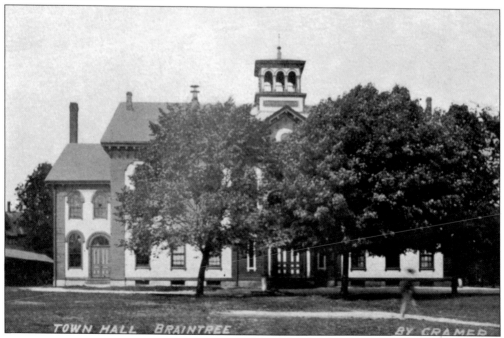

TOWN HALL BRAINTREE BY CRAMER

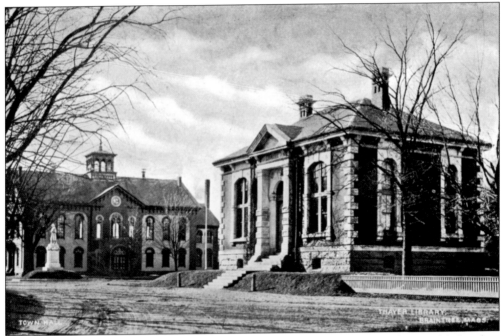

These two photographs of the original Thayer Public Library, looking south, were likely taken around the beginning of the 20th century. The above photograph gives a clear indication as to where the old town hall and Civil War monument were located. The primary benefactor of the library was Gen. Sylvanus Thayer. In 1870, the retired "Father of West Point" made a substantial contribution (and loan) to the town for the construction and future care of the library. Although Thayer died before the library was completed, his name was permanently attached to the institution he helped build. The ivy-covered library seen below captures the beauty of this impressive structure. Note the hitching posts on either side of the front steps and the horse sheds located behind town hall.

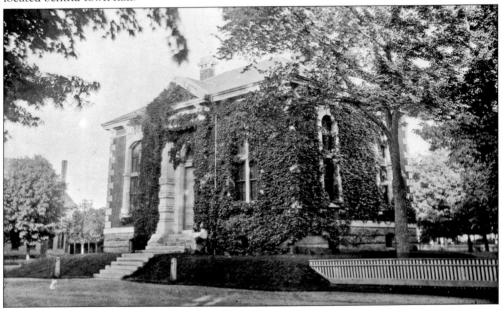

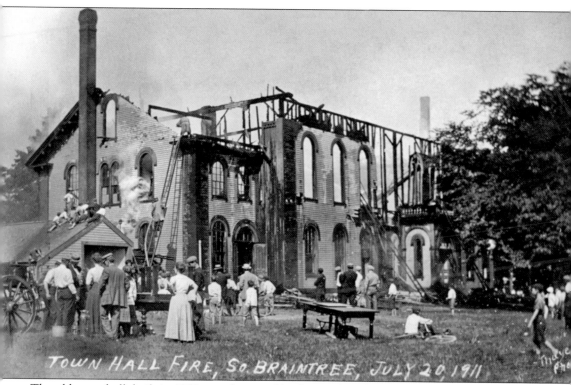

TOWN HALL FIRE, So. BRAINTREE, JULY 20, 1911

The old town hall, built in 1858, was destroyed by fire on the afternoon of July 20, 1911. Many down-turned heads can be seen among the crowd gathered on French's Common to view the destruction. Several young boys climbed onto the town house shed to watch as the firefighters finished putting out the blaze. Fortunately, there was time for many of the town's records, including the birth records of John Adams, John Hancock, and John Quincy Adams, to be removed from the building. It appears from this picture that some of the furnishings of the building were saved as well.

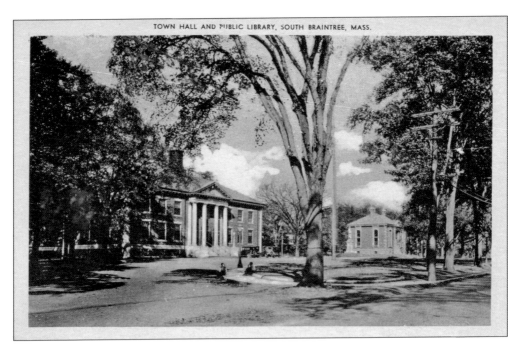

The new (current) Braintree Town Hall was dedicated on June 26, 1913. The impressive Georgian-style building faces east toward Washington Street, rather than north like the previous town house. The new building was substantially larger than its predecessor and was made of brick instead of wood. The scene captured in the above photograph, taken between 1915 and 1920, looks similar to what passersby see today. The picture below was likely taken in the 1920s. Note that the Civil War monument was still located between the town hall and Thayer Public Library. It was later moved to the town hall mall, seen in the foreground.

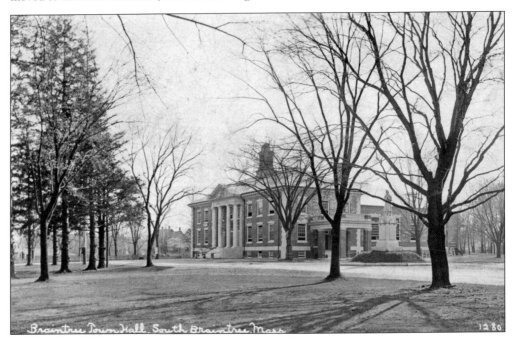

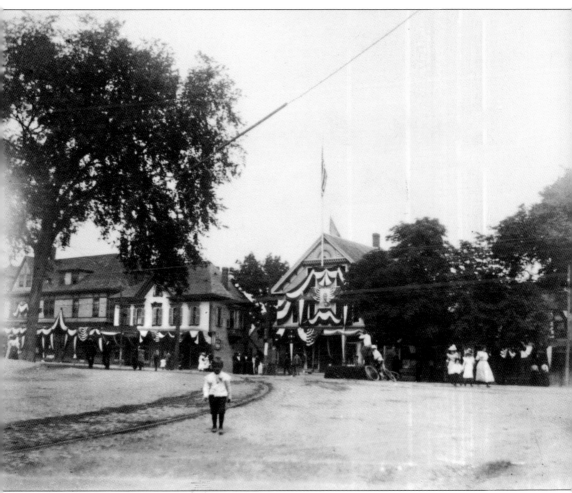

Beginning in 1872, the Town of Braintree began to appropriate funds to pay tribute to those who gave their lives in service to their country. Decoration Day (now Memorial Day) was celebrated on May 30, and the events of the day were overseen by members of the Grand Army of the Republic (GAR). After these Civil War veterans decorated the graves of the war dead, they usually led a parade through the center of town. The GAR was later joined by members of the American Legion and Veterans of Foreign Wars, as they paid tribute to those who gave their lives in future conflicts. One of the earliest known photographs of South Braintree Square, this picture was taken during a Decoration Day celebration in the early 1890s.

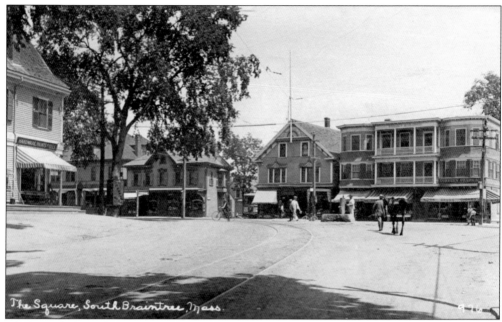

The Square, South Braintree, Mass.

The leisurely lifestyle of early-20th-century America is reflected in the above photograph of South Braintree Square, taken before 1910. As one man operates a public water pump, another leads his horse to the trough for a drink. A young boy on his bicycle crosses the trolley tracks, perhaps lured by the ice-cream sign on the tree, while a trolley car can be seen emerging from the trolley yard between the two buildings (both of which are still there) in the center of the picture. The photograph below was taken from almost the same spot during the same time period. The bicycle leaning against the curb in front of Maucha's barbershop and the fruit on display at the market are all that suggest that the work day had begun.

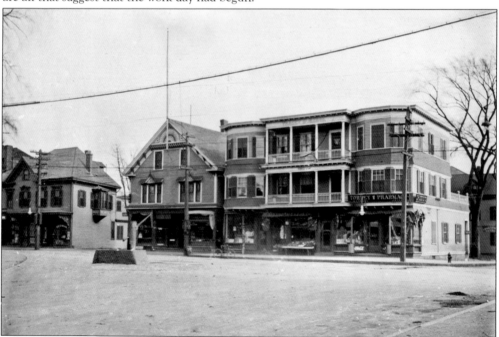

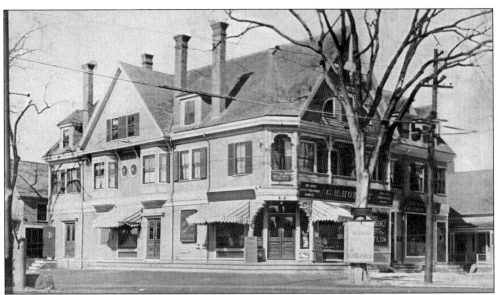

C. H. Hobart's store (above) was a popular gathering place in South Braintree Square for many years. Local residents often sat on the store steps to catch up on local events, talk with their friends, gossip, rest, or simply observe people going about their daily lives. Mulligan's Restaurant is now located at this site. Not far from the steps of Hobart's was a public pump and watering trough (right). There were three such pumps and troughs in Braintree. Authorized by a town meeting in the 1860s, they were installed "for the use of man and beast." The other two were located in Braintree Square and East Braintree. The awnings and open door at Hobart's general store remind one of a time before air-conditioning.

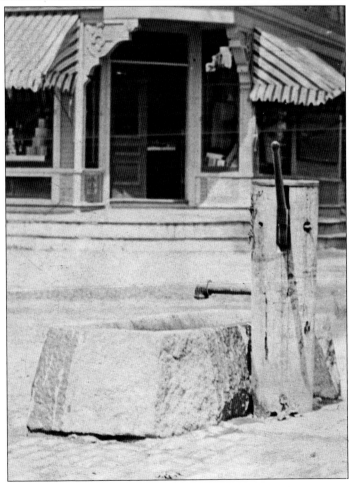

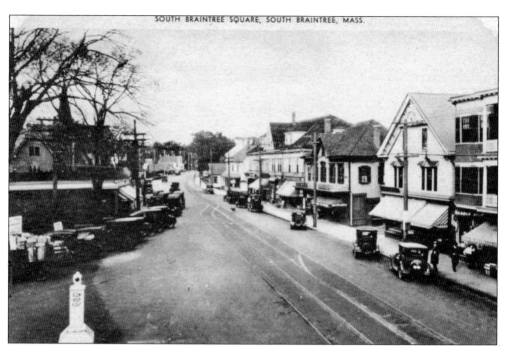

This picture of South Braintree Square (above) from the early 1920s was likely taken from a second-story window above Reordan's Market (now Braintree Rug). It reveals a much busier and faster lifestyle than that reflected in photographs taken just a decade earlier. Horses and bicycles have been replaced with automobiles, and the water pump was replaced with a traffic sign reading, "Slow Keep Right." The cold, wintry scene captured below was taken during the same decade and depicts a similar flurry of activity.

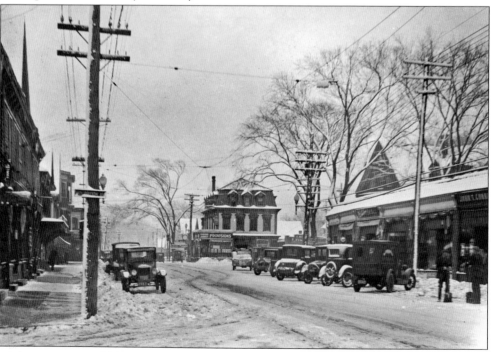

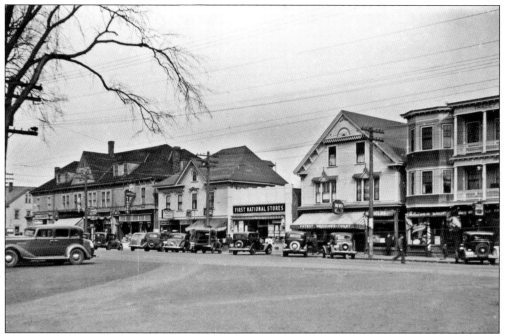

South Braintree Square was busier still in the 1930s. A slight discoloration on the street is all that is left to remind people of where the trolley tracks once ran. As for the trolley yard, it was replaced by a First National grocery store, one of many chain stores that spread throughout the community in the coming years. Fisher Experience is now located in this building.

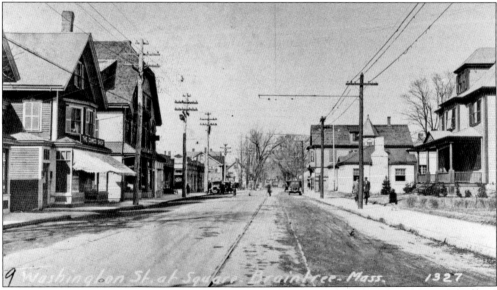

This image of Braintree Square, looking north, was taken in 1925. The house on the right, owned by Dr. Ernest Bent, a dentist, is now the site of a branch office of the Braintree Cooperative Bank. Next to Bent's house is the Masonic temple, which was later sold to the Veterans of Foreign Wars, Post 923. The large building on the left across from the Masonic temple housed Cutcliffes Market and G. E. Loring and Company. All the buildings on the left are still standing. Note the trolley tracks running down the middle of the road.

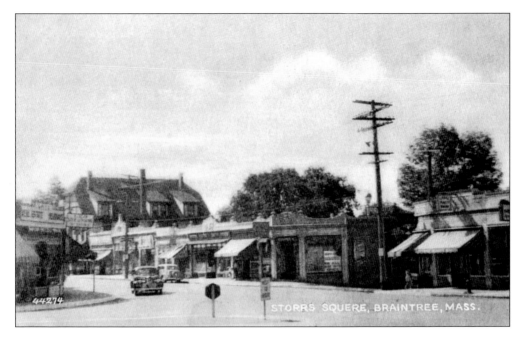

STORRS SQUERE, BRAINTREE, MASS.

Braintree Square has not changed that much since these two photographs were taken in the 1940s. Although there are far more automobiles today, the profile of the square remains remarkably the same. The water pump, located in the middle of Storrs Square for several decades, had long since been removed when this picture was taken. The trough now resides at the Braintree Historical Society on Tenney Road. The large building that once housed Cutcliffe's Market can still be seen in the distance to the left. The image below, likely taken on the same day, centers on First Congregational Church in the distance.

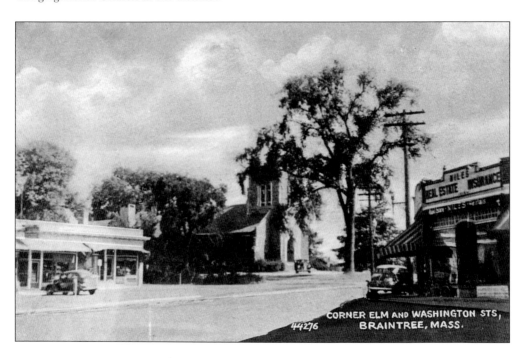

CORNER ELM AND WASHINGTON STS, BRAINTREE, MASS.

Two

Down East

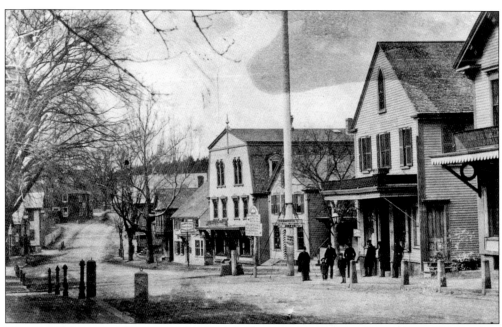

This very old picture of Weymouth Landing, looking west toward East Braintree, was likely taken in the 1870s. Long before automobiles dominated the landing, the hitching posts seen on both sides of the street reflected the importance of the horse for transportation. Just beyond the water pump and trough was the business of J. H. Wallace, "Practical Horseshoer," located two doors down from the livery stable. The only people on the street are gathered in front of the dry-goods store. The building on the extreme right housed the *Weymouth Gazette*.

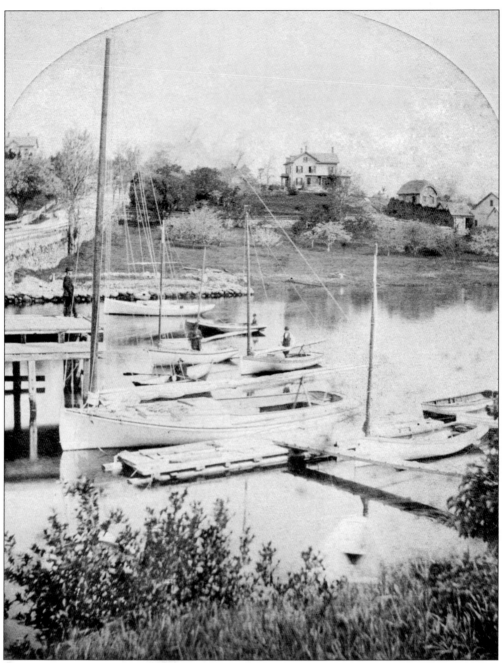

This early image of Quincy Avenue, taken in 1885 from the south side of the Fore River, focuses not only on the boat landing, but also on the home and farm of Thomas Watson. After Watson arrived in Braintree in 1883, just seven years after his breakthrough work on the telephone with Alexander Graham Bell, he built his house and farm buildings along the eastern slope of Quincy Avenue. Within a few short years, the empty field seen along the water's edge (below Watson's house) became home to Watson's Fore River Engine Company. It is not known whether the man standing at the end of the pier to the left is Watson. The person taking this photograph would have been standing right next to the tollhouse.

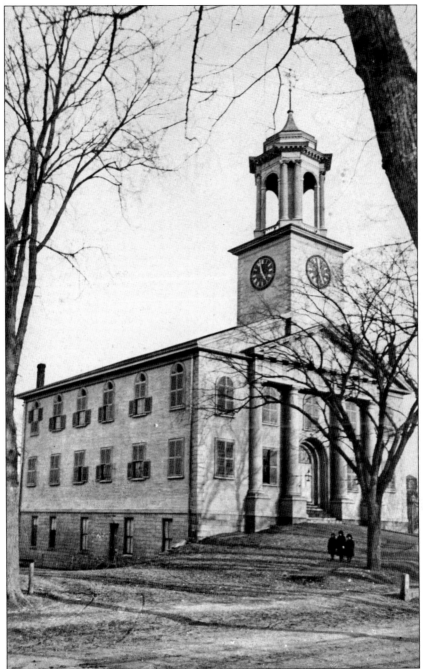

Built in 1789, the Hollis Street Church was first located in Boston. It was dismantled and moved to its new site in East Braintree in 1811 (on land now occupied by the East Braintree/Weymouth Landing train station). Renamed the Union Church, this beautiful structure was a landmark in East Braintree/Weymouth Landing for almost 90 years. Rev. Jonas Perkins served as pastor (and later pastor emeritus) of the church from 1815 to 1874. The building was destroyed by fire in 1897 when sparks from a passing train ignited the structure. The new Union Congregational Church was built nearby on Commercial Street farther away from the trains.

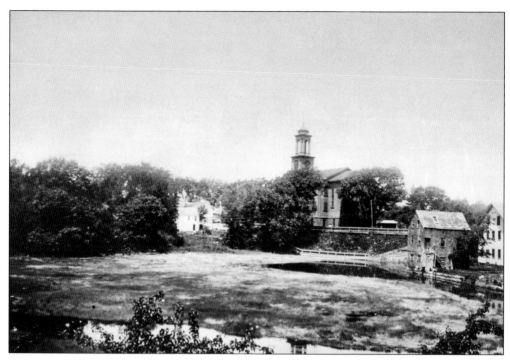

This rear view of the Union Church (above) was taken from the Weymouth side of Smelt Brook, the dividing line between the two towns. The white building on the far right (next to the mill) is a fan factory. The railroad tracks run along the ridge between the church and the mill, and the stone wall on the other side of the mill is the railroad abutment. Smelt Brook runs under the railroad bridge and out to the Fore River. Another view of the rear of the Union Church (below), taken from a greater distance, captures a unique view of Quincy Avenue. In the distance to the right, one house sits alone on a vast open green hill.

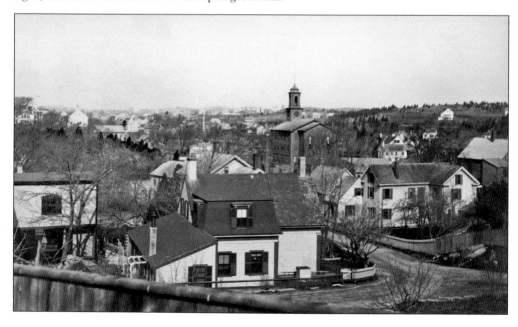

Posing beside the old tollhouse on the southern side of the Quincy Avenue bridge are, from left to right, Cordella (Thomas) Whitmarsh; her husband, Capt. Samuel E. Whitmarsh; Samuel Freeman Whitmarsh; and Lillian F. (Whitmarsh) McCoy. Samuel Freeman was the bridge tender. The image below captures several neighborhood boys take a refreshing dip in the Monatiquot River on the westerly side of the Quincy Avenue bridge. The tollhouse can be seen in the center of the picture on the south end of the bridge. The picture incorrectly states that the bridge was between Braintree and Weymouth. The Smelt Brook, located a few hundred yards to the southeast of this spot, is actually the dividing line between the two towns.

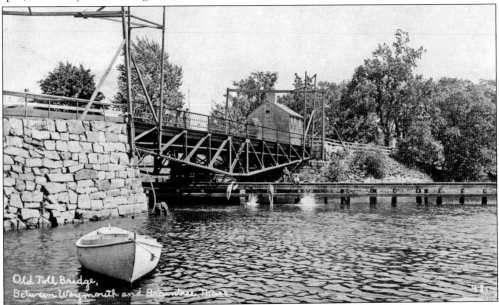

Old Toll Bridge,
Between Weymouth and Braintree, Mass.

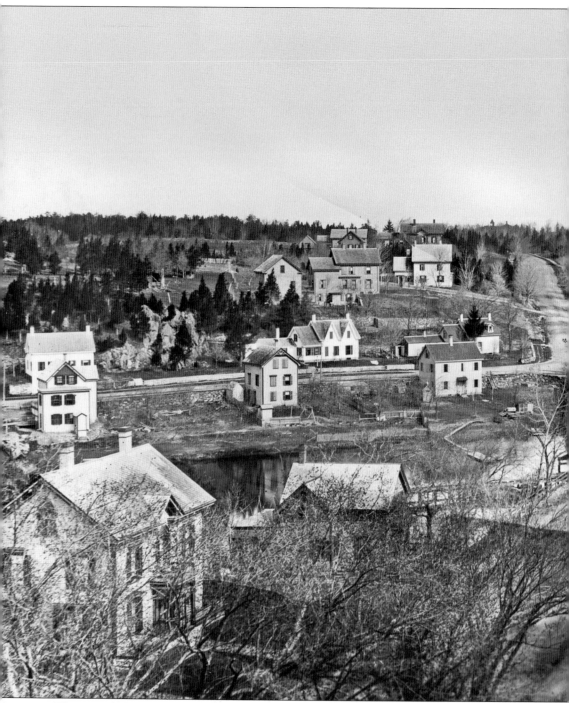

This incredible picture of Quincy Avenue, looking north, was taken from the belfry of the Union Church around 1890. Thomas Watson's Fore River Engine Company now dominates the northern shore of the Fore River just beyond the Quincy Avenue bridge to the right. The tollhouse is located just before the bridge on the right. Watson's white house with the wrap-around porch, facing his business, remains the only residence on the eastern (right) side of Quincy Avenue. Aside from

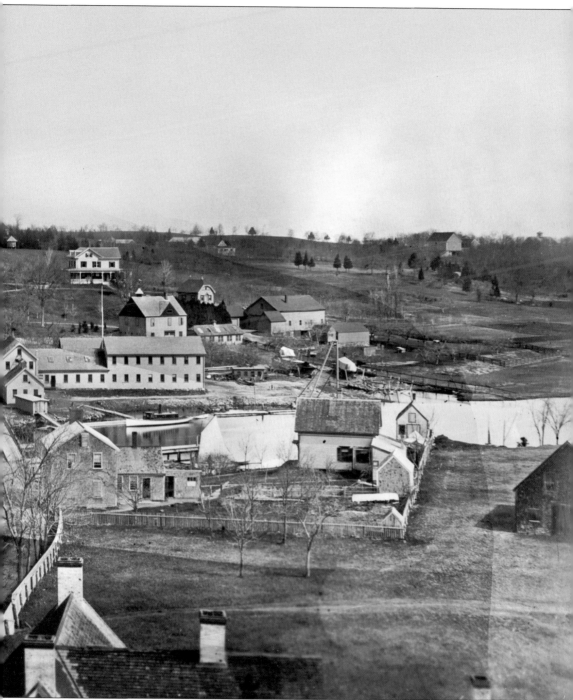

a few of the homes seen here on Allen Street and Cedarcliff Road, few landmarks remain from this scene of 120 years ago. Among other streets, Gordon Road, Edgehill Road, Beechwood Road, Ardmore Street, Arbor Way, Arthur Street, Argyle Road, and Watson Park now occupy the land that once belonged to Watson.

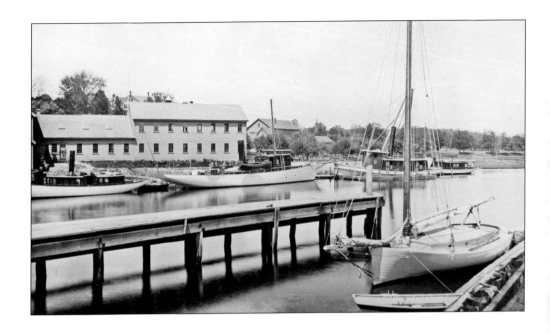

Thomas Watson's Fore River Engine Company (above, left) serves as the backdrop to this busy maritime scene in 1891. The large yacht in front of the engine works was the *Philomena*, owned by Allen Amory of Braintree. The sloop in the foreground was the *Good Intent*, owned by Capt. Samuel E. Whitmarsh. The pier seen next to the *Good Intent* extended under the bridge. The young boys seen in lower picture on page 27 were jumping off the western end of the pier. This picture captures the eastern end of the same pier. The photograph below was likely taken on the same day in 1891 from the bridge on Quincy Avenue. Judging from the pier, however, this picture was taken at high tide.

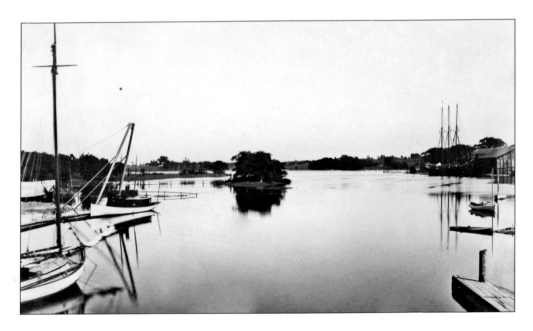

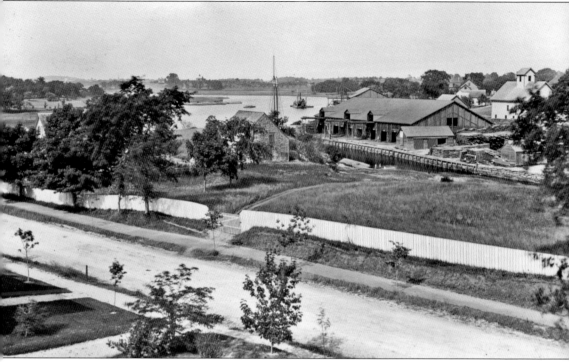

Taken from the cupola of the Bowditch house on Quincy Avenue in June 1891, this picture looks east toward the field and path located between the Union Church and the tollhouse. Smelt Brook can be seen just beyond the field. Rhines Lumber Yard was located on the Weymouth side of the brook. The beautiful open fields on the northern side of the Fore River (left) were owned by Thomas Watson (now Watson Park). Note the well-maintained road and sidewalks, with several recently planted saplings along both sides of Quincy Avenue.

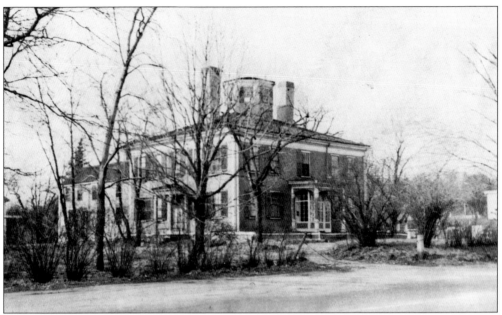

A great example of Federal-style architecture, this house was built in 1809 or 1810 by Samuel Miller Thayer on Quincy Avenue just north of what is now the Lucid Funeral Home. It was later owned by Gilbert Nash and Granville Bowditch. It was from the cupola of this house that the picture on the previous page was taken. The house was demolished in 1940 shortly after this picture was taken.

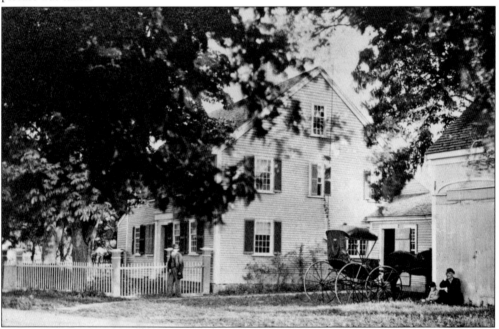

This was the home of Rev. Jonas Perkins, who served as pastor of the Union Church for 45 years and pastor emeritus for another 14 years until his death in 1874. The parsonage was located near land that later became the Jonas Perkins School. Perkins also operated a private preparatory school out of this house. This picture was likely taken in the 1880s after Perkins's death.

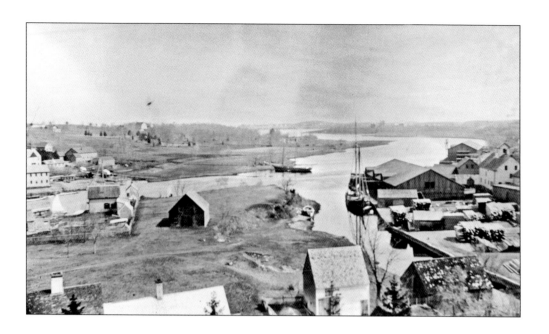

The above image, taken from the belfry of the Union Church in 1891, looks north down the Fore River. Watson's Fore River Engine Company can just be made out on the far left next to acres of open space. The Smelt Brook and Rhines Lumber Yard can be seen to the right. One lumber schooner appears to be tied up at Rhines ready to pick up a load, while a second schooner (facing Watson's property) waits on the Fore River. In the picture below, two lumber schooners (perhaps the same two seen above) are tied up on the East Braintree side of the Fore River opposite Rhines Lumber Yard and Richards Coal Wharf in Weymouth. The schooner in the foreground is identified as the *Dolphin*. The bows are pointed toward what is now Watson Park.

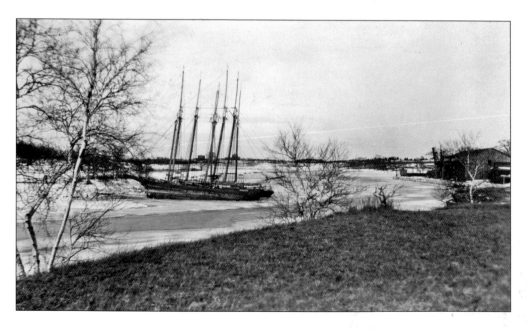

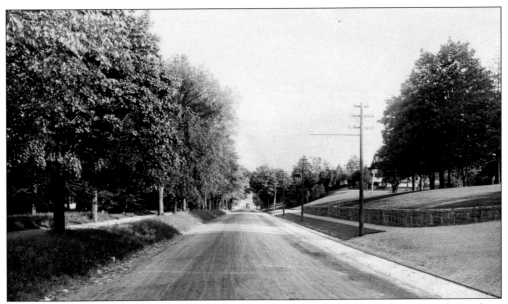

This beautiful view of Quincy Avenue, looking south toward the bridge and Weymouth Landing, captures the slow-paced lifestyle of the early 1900s. The raised and well-maintained sidewalks suggest a people accustomed to walking, and the narrow wagon wheel marks (and horse droppings) in the middle of the street attest to the primary means of conveyance.

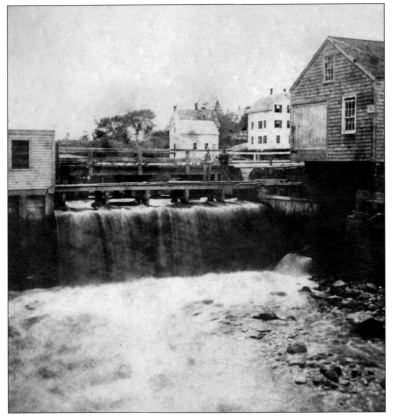

This view of the Shaw Street bridge and dam on the Monatiquot River was likely taken between 1895 and 1905. The white structure on the left is Ambler's Grist Mill, and the shingled building on the right is Jordan's Blacksmith Shop. These two operations are good examples of the type of businesses that thrived on and were powered by the Monatiquot River for more than 300 years.

This view of Liberty Street, looking uphill from Union Street, was likely taken between 1915 and 1920. The Jonas Perkins School would have stood to the left of the photographer. With few cars traveling the unpaved streets of Braintree, the gentleman seen in this picture walks without worry in the middle of the road. The houses in this picture are still there. The photograph at right, taken just a short distance away on Union Street in the early 1920s, looks east toward Commercial Street and Weymouth Landing. An automobile is about to turn right onto Commercial Street.

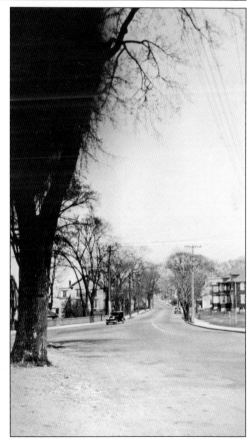

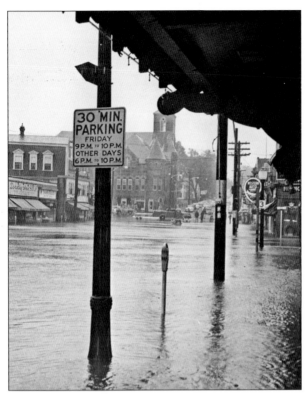

It is unlikely that the 30-minute parking restriction in Weymouth Landing was a problem on the day this picture was taken in 1948. Braintree Police and Fire Department personnel closed off the street and were forced to use rowboats to check on local businesses. The Sacred Heart Church, however, seen in the distance at left, remained dry. Although located in Weymouth, Sacred Heart Church has served the people of East Braintree since 1871. The church pictured was completed in 1882. It was destroyed by fire in 2005 but was rebuilt within a year. The picture below was taken a few years after the flood from the railroad tracks, looking east across the Braintree municipal parking lot. The rear of Sacred Heart Church can be seen in the distance.

Three

MAIN STREETS AND BACK ROADS

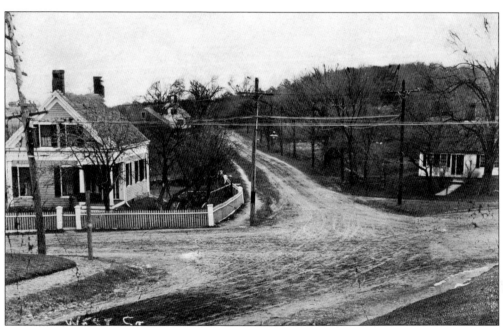

Braintree Five Corners was a much different place in the 1890s. With no sign of life at this major intersection, the viewer is reminded of how few people were living in the town in the late 19th century. In the center of the picture is West Street, sloping uphill toward Washington Street. Granite Street can be seen on the left, and Franklin Street is to the right. While the house in the left foreground is no longer there, one of the two houses behind it on West Street is still standing.

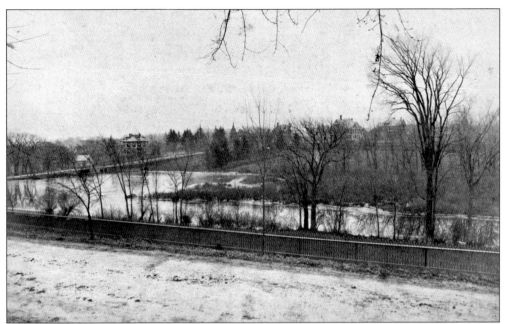

This beautiful picture was taken on Elm Street, likely in 1891, looking southeast across the Monatiquot River and Morrison's Pond toward Middle Street. Apartment buildings now occupy the land along this stretch of Elm Street. This view below from Elm Street, looking south toward Middle Street, was likely taken on the same day. The large house in the center of the picture on the westerly side of Middle Street belonged to Elmer Morrison, son of Alva Morrison, who founded Morrison's Mill. The house is still there, minus the tower. The large body of water in the foreground was called Morrison's Pond, first created when a dam was constructed at "the falls" (at the foot of Middle Street) in 1645 by John Winthrop Jr. to help power the ironworks, located at the future site of Morrison's Mill.

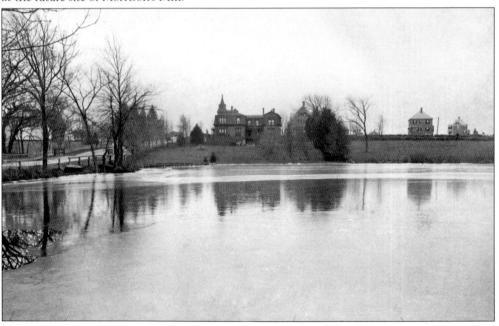

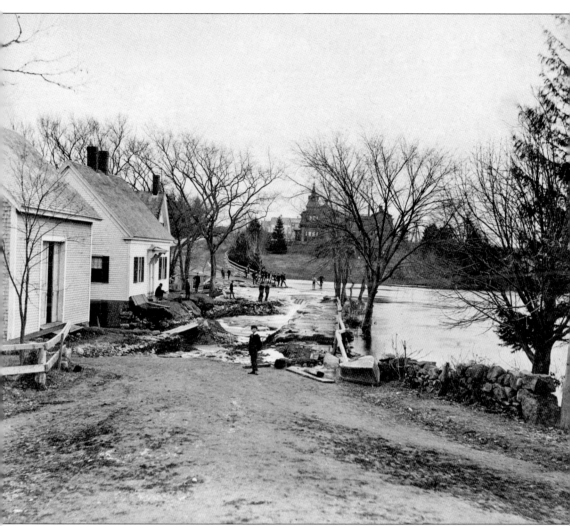

Taken at the intersection of Middle and Elm Streets, this picture captures the damage done by the Flood of 1891. When the dam and bridge at the foot of Middle Street were washed out by heavy rains, a large section of Middle Street broke apart and disappeared downstream. An elderly gentleman can be seen sitting on the stoop of his house, just a few feet from the encroaching Monatiquot River. Note the two wooden planks connecting what is left of his front yard to his nearby barn. Several neighbors stand near the floodwaters and watch as Morrison's Pond is slowly drained. Generations of Braintree children ice-skated on this pond. Middle Street was later raised to accommodate the railroad bridge overpass just before Morrison Road. The Elmer Morrison house can be seen farther up the street to the right.

This recently discovered picture (above) was taken at the highest point on Middle Street, looking northwest over Morrison's Pond toward the tower of the First Congregational Church. When this picture was taken, there was no bridge overpass at the top of Middle Street, and the hill that currently leads to the overpass was not yet built. Today it looks as though the homes on the north side of the tracks were built at the bottom of a hill, but they were not. The hill came later. The First Congregational Church tower is seen from yet another angle, below. This picture was taken on Cochato Road, looking east toward Braintree Square. The large, open field seen in the foreground is now home to the Archbishop Williams High School football team.

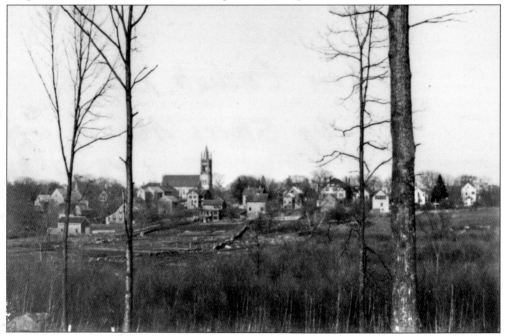

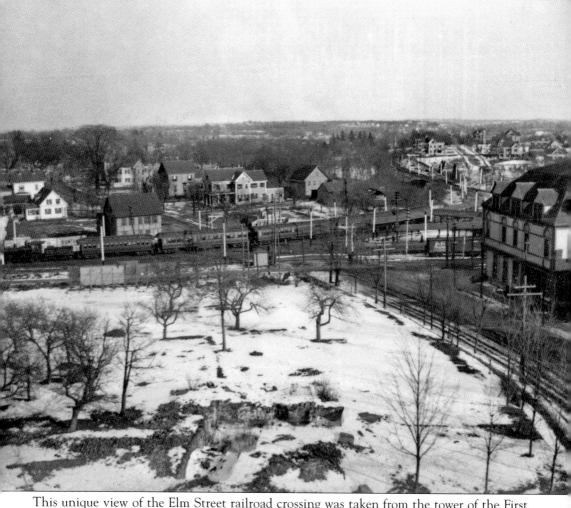

This unique view of the Elm Street railroad crossing was taken from the tower of the First Congregational Church at the beginning of the 20th century. Looking east, the photographer likely waited for a Boston-bound train to pass before snapping the picture. Long's Hall can be seen to the right. Although trains still run along the same right-of-way, there is now a bridge over the tracks. And a reconfigured Elm Street was moved farther north, cutting into the snow-covered slope seen in this picture. From there, it proceeded straight over the tracks, requiring the removal of the houses seen in the upper left.

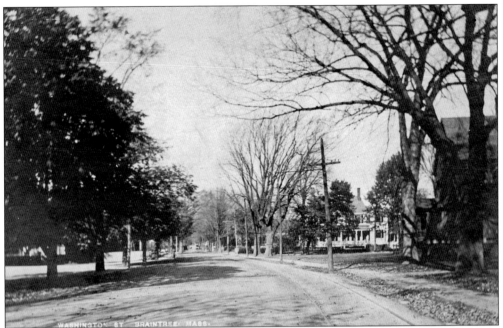

Taken between 1910 and 1920, this view of Washington Street, looking north toward Braintree Square, captured the tranquil and quite typical Braintree streetscape of the period. This beautiful tree-lined street was representative of other streets in town. Note the trolley tracks on the easterly side of the road. Below, another view of Washington Street, looking north toward Braintree Square, was taken after a winter snowstorm between Hollis and May Avenues. The trolley tracks are a bit more noticeable in this picture.

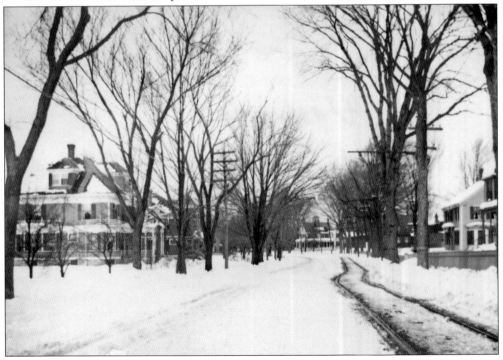

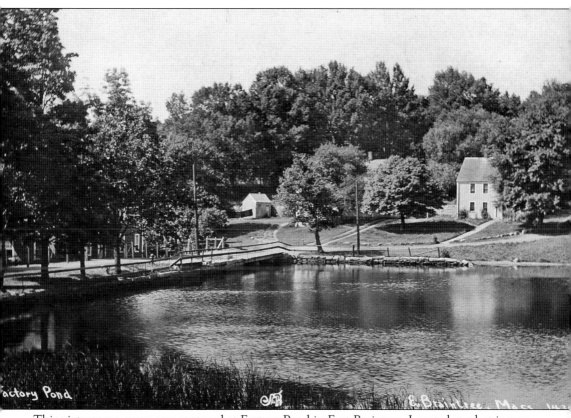

This picturesque scene was captured at Factory Pond in East Braintree. Located at what is now Braintree Village (Monatiquot Village), Factory Pond had a long and storied history, as several businesses operated next to the dam that formed the pond for more than 200 years. The dam was demolished in 1972, and the pond was filled in to make way for Monatiquot Village.

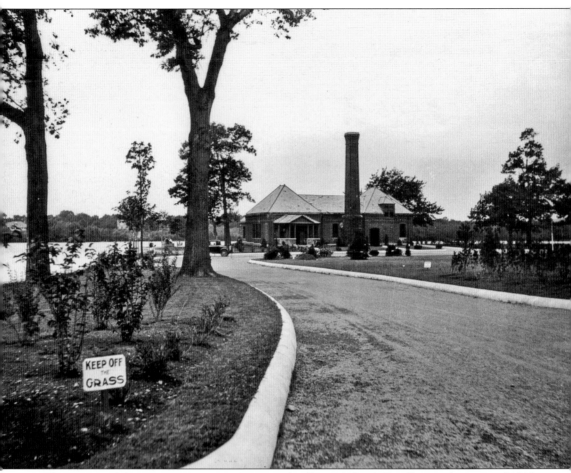

This picture of the pumping station at Sunset Lake (formerly Little Pond) was taken around 1920. Before Great Pond became the sole source of drinking water for the town in 1913, water from Sunset Lake was often used. It was not until 1916 that swimming and boating were permitted at Sunset Lake. Two years later, bathing was permitted, and bathhouses were built next to this station. This pumping station, which was built in 1883, was demolished in 1973.

The picture above was taken by Emma Bouchard from her upstairs bedroom window when she was a young girl living at 119 Lakeside Drive. It looks southeast in the direction of Braintree Square. If Bouchard had turned her camera to the right, she may have captured the scene below, as the Quincy Reservoir (Braintree Dam) was located directly across the street from her house. As this photograph attests, the reservoir was a popular place to picnic, swim, and boat in the 1920s. If Bouchard turned her camera even farther to the right, she would have captured the large Pantano farm on land now occupied by the South Shore Plaza.

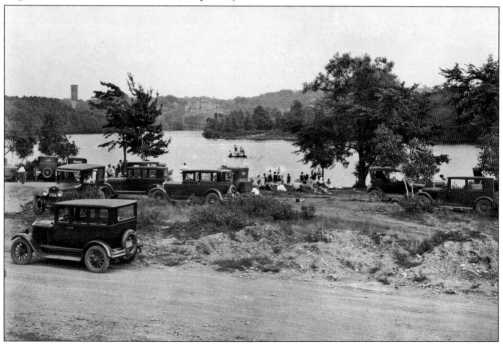

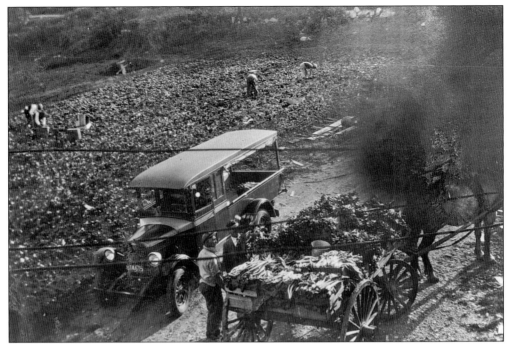

Many Braintree farms survived well into the 20th century. One of the largest was the Pantano farm, located on land that is now the South Shore Plaza. This picture, taken in the 1920s, shows a horse-pulled wagon loaded with produce freshly picked at the North Braintree farm. The Pantano family had a farm stand on Granite Street, a popular stop for Braintree families for many years.

This impressive image captures a large section of Arnold's farm in East Braintree just before the dawn of the 20th century. The Neal house is located on the distant side of the stone wall. Sections of stone wall similar to this, originally built to mark farm boundaries, can still be found throughout the town. East Junior High School currently occupies the land seen in this picture.

The Asa French orchard was located on Washington Street directly across from town hall and adjacent to the French house. Town hall is seen through the trees. The second Thayer Public Library was built on this site in 1953 (the same site as the current library). The photograph below, taken in the same general vicinity, captures a bulldozer breaking up the land on the French estate across from Braintree Town Hall to make way for Washington Park Avenue (later Gilbert Bean Drive) and Tenney Road. This picture was likely taken in the fall of 1938, as the banner hanging across Washington Street reads, "Vote Republican Saltonstall & Cahill." Braintree remained a solidly Republican town until the 1960s.

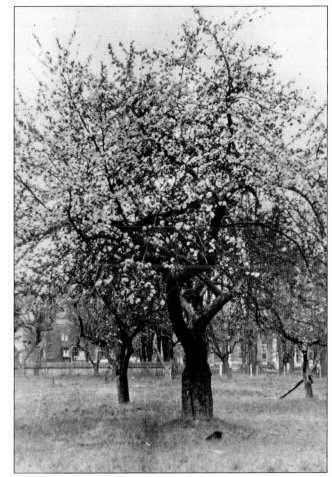

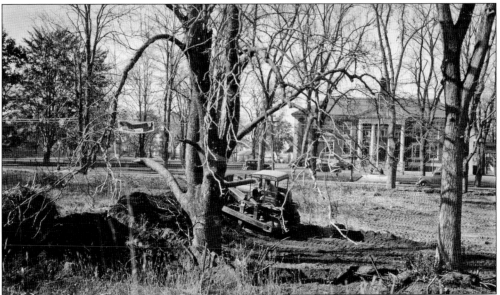

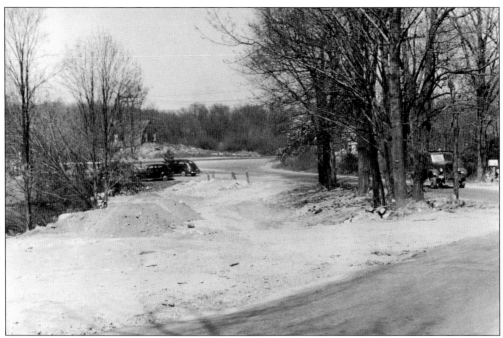

After World War II, the town of Braintree, like many communities in the country, underwent a building boom. With the help of the GI Bill, returning veterans purchased homes in the suburbs. One of the more popular suburbs in Massachusetts was Braintree, and the landscape of the town began to change dramatically. The picture above was taken in 1951 at a spot that is now on Hickory Road where it meets Liberty Street. It looks north toward the Grove Street intersection. The picture below was likely taken on the same day in 1951 on Liberty Street near its intersection with Forest Street, looking south. (Both, courtesy of Braintree Highway Department.)

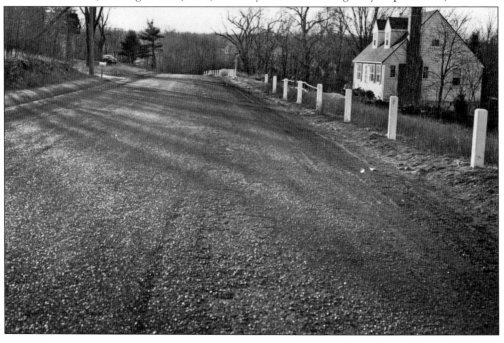

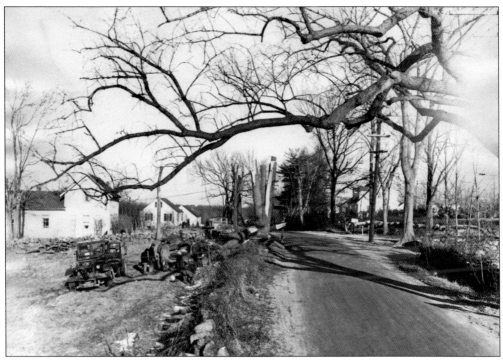

These two pictures capture the physical transformation of the land on Liberty Street in 1951. The above image was taken after several trees underwent a first cut. These workers are beginning to clear land near the Forest Street intersection. Although a house now occupies this site, a section of the stone wall seen in the distance is still there. The picture below, looking south, was also taken on Liberty Street, which was still a dirt road, across from where St. Clare's Church now stands. Note the truck driving down Peach Street on the right. (Both, courtesy of Braintree Highway Department.)

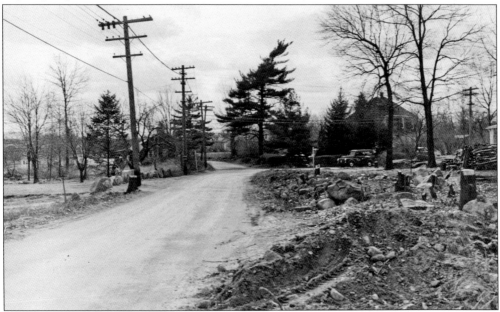

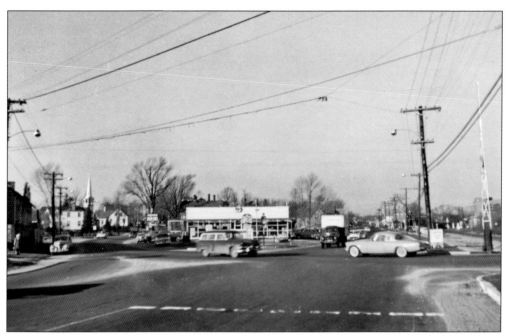

Along with the growing population of the postwar years came a sharp increase in the number of automobiles driving through town. By the early 1950s, the streets of Braintree began to resemble what is seen today. Looking north at the Washington, Hancock, and Plain Streets intersection in the 1950s, this picture (above) captures the growing congestion. The service station in the center is now home to Dunkin Donuts. South Congregational Church can be seen in the distance to the left, and the railroad crossing can be seen to the right. The view below was taken on Hancock Street looking north just before the Washington and Pearl Streets intersection. The Braintree Rug building can be seen in the distance to the left.

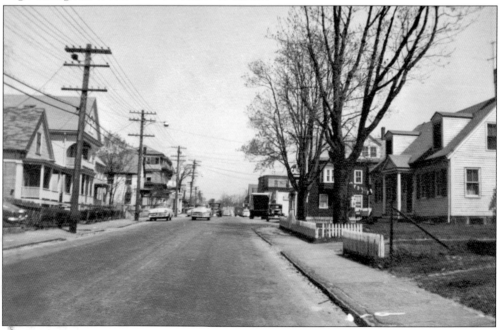

Four

HOMES AND
HOUSES OF WORSHIP

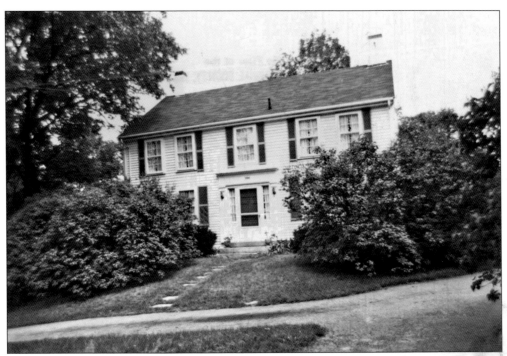

Located on Liberty Street directly across from the roadwork seen on page 48, the Nash-Penniman house has seen many changes in Braintree. Built in 1695, this great example of a Colonial era saltbox-style home is one of the oldest structures in Braintree.

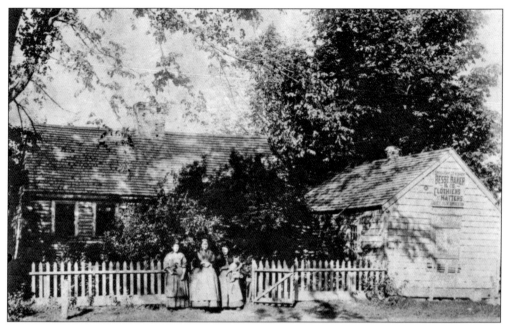

This early photograph, likely taken in the 1880s, captures three ladies (one holding a cat) posing in front of the John Tower/Sarah Friel house. One of the women may have been Besse Baker. The sign on the building to the right reads, "Besse Baker & Co., Clothiers and Hatters." The house was located on the west side Washington Street just north of South Street in the Braintree Highlands. The house was torn down around 1900.

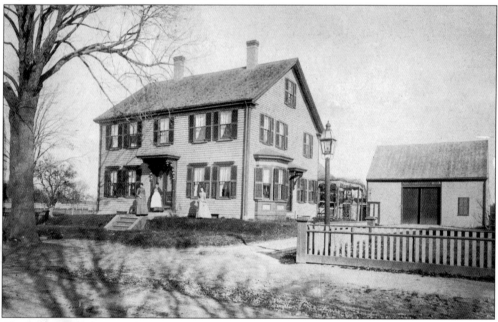

This house and barn were built by Moses Arnold in 1803. They were located in Braintree Square at 444 Washington Street near Webster Road. The three ladies standing in the front yard were likely members of the Marcus Arnold family. Arnold owned a business in the lyceum building. This house was demolished in 1954 to make way for the telephone exchange building.

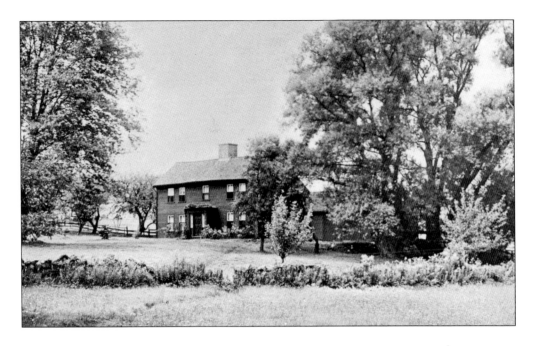

The 1890s picture above shows the Gen. Sylvanus Thayer birthplace at its original site on Washington Street on land currently used by Thayer Academy for its soccer fields. The house was built by Nathaniel Thayer in 1720. Another view of the Thayer house, taken after 1940, is shown below. The house was purchased by the Walworth Manufacturing Company in 1957 and was turned over to the Braintree Historical Society on the condition that it be moved. The society moved the house to its present location across from town hall. It has been restored to its 1785 appearance, the year Sylvanus Thayer was born.

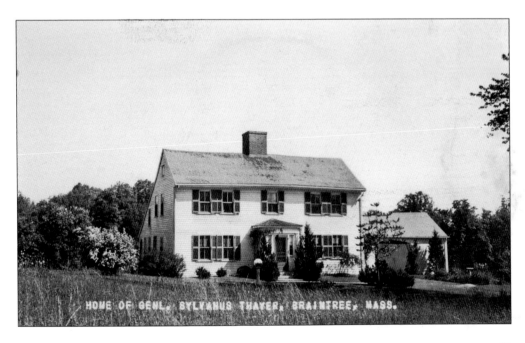

HOME OF GENL. SYLVANUS THAYER, BRAINTREE, MASS.

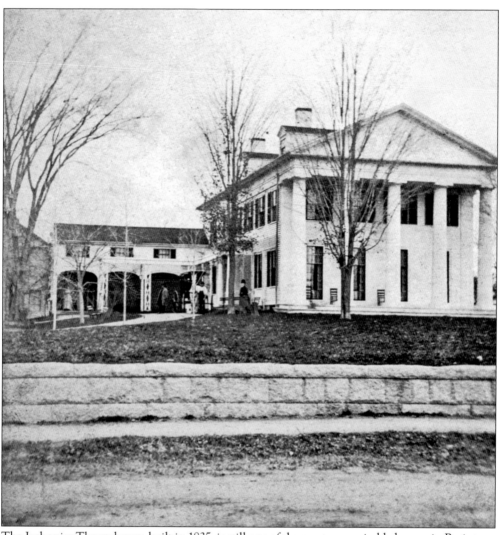

The Jachonias Thayer house, built in 1835, is still one of the most recognizable houses in Braintree. Thayer, a shipping merchant, built this house near the 1640 home site of his ancestor Thomas Thayer. This Greek Revival house was owned by several different families, as well as the Archdiocese of Boston for its use as a convent for the Sisters of Nazareth, who taught at the St. Thomas More School. This picture was taken in the 1890s.

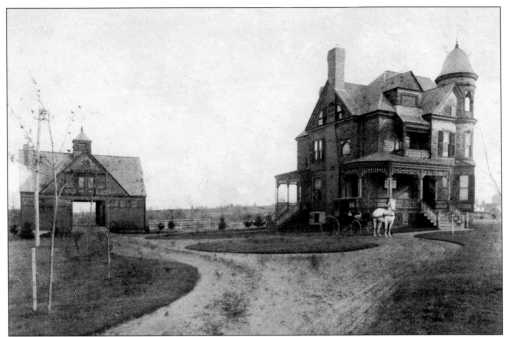

The Italianate-style home of Ibrahim Morrison is pictured here in the early 1890s. With the carriage house doors still open, Morrison may have just removed his horse and buggy for a short trip down Middle Street to his business at Morrison's Mills. Far into the distance between the carriage house and the main house was Arnold's farm, the land on which East Junior High School was later built. Although modifications have since been made, the house still stands.

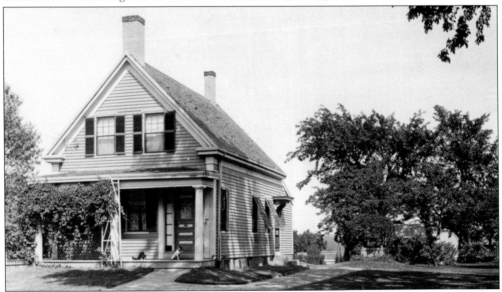

Originally located on Washington Street near Capen Circle, the Samuel Veazie house was built in 1832. Facing demolition for highway improvements in 1979, it was moved to a piece of property in front of South Middle School, where it served as the Highlands Branch of the Thayer Public Library for more than 20 years. It was demolished after the main library branch on Washington Street was replaced with an expanded, modern facility.

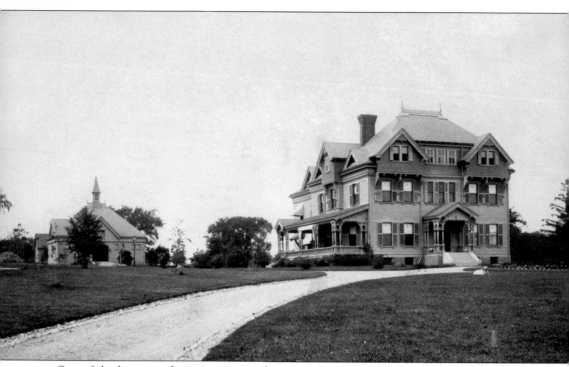

One of the largest and most impressive homes in Braintree, the Samuel Thorndike house was located at the corner of Elm and Cedar Streets. The home of Benjamin Vinton French was originally located on this site, but it was torn down in the 1870s to make room for this house. The Thorndike house was razed in 1920 to make room for Hawthorn Road. The carriage house seen to the left was converted into a private home that still stands at 23 Cedar Street.

This picture of the Tracey house, located at 820 Washington Street in South Braintree Square, was likely taken before 1915. William Sumner Tracey owned the Tracey building in South Braintree Square at the northeast corner of Washington and Pearl Streets. Tracey built many homes in Braintree along Hollingsworth Avenue. While the Tracey building was torn down in the 1960s (now a parking lot for McDonald's), his house still stands.

With a grocery store on the first floor and living space on the upper floors, this house was built on the southeast corner of Washington Street and Hall Avenue in South Braintree Square. Although it has undergone extensive renovation during the past 90 years, the building is still there.

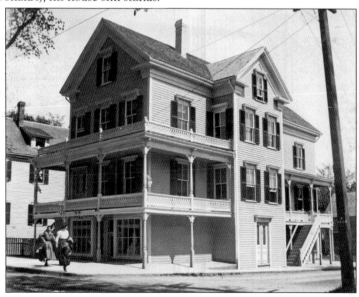

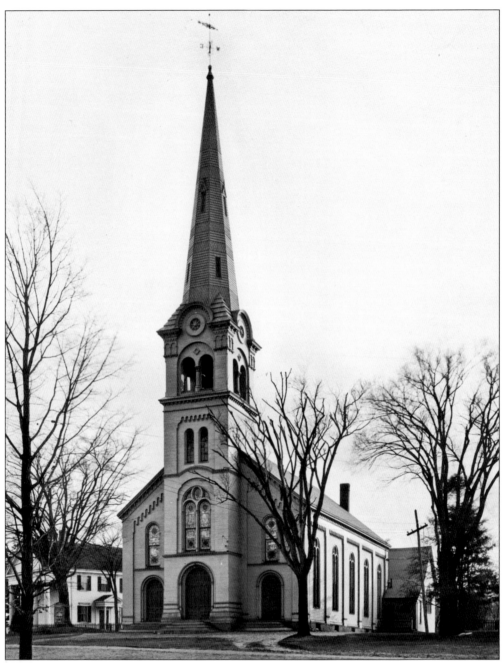

The oldest, and quite possibly most photographed, church structure in Braintree, the South Congregational Church has changed little since it was captured here in the 1890s. After the original church was destroyed by fire in 1860, this building was constructed the following year. The original parsonage still stands across the street from the church at 1090 Washington Street. The Hollis Institute, which is now a private residence, can be seen to the south of the church.

This view of the South Congregational Church, although slightly hazy, captures the slow-paced life of late-19th-century Braintree. Before automobiles and paved roads, travel was slow and easy, as evidenced by this man riding his horse-pulled rig around the corner onto Pond Street.

This picture of the new Union Congregational Church on Commercial Street was taken in the early 1900s. After the original Union Church was destroyed by fire in 1897 (started by the sparks of a passing train), the new structure was built on this hill far from the train tracks. The cornerstone for this church was laid on May 15, 1898. Before automobiles controlled the streets, people felt comfortable sitting on the curb, perhaps waiting for the trolley.

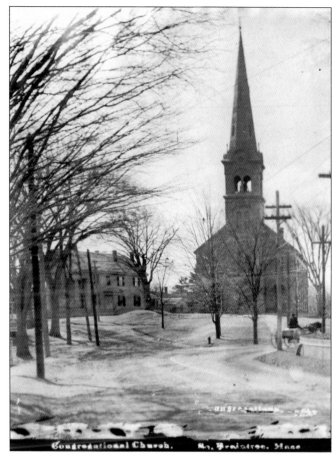

Congregational Church. So. Braintree. Mass.

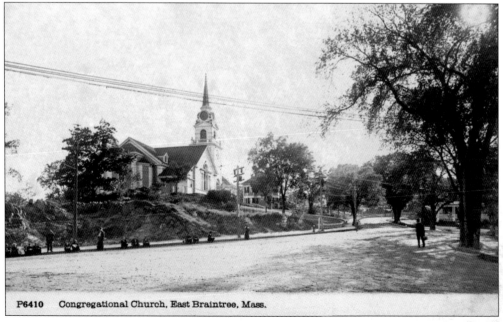

P6410 Congregational Church, East Braintree, Mass.

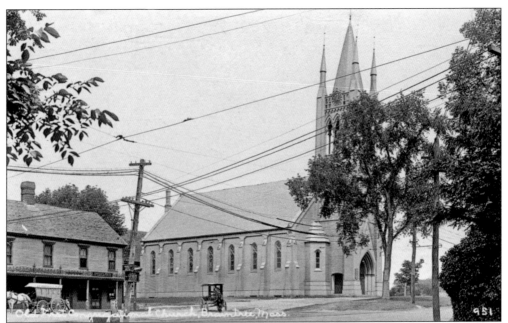

This view of the First Congregational Church and lyceum was likely taken at the beginning of the 20th century, certainly after 1896, as the Ebenezer Thayer house is no longer present on the east side of the church. Although the horse-pulled wagons and town pump are still being used, new utility poles reflect the changes taking place. The large sign on the pole points east and reads, "Elm Street, E. Braintree, Weymouth, Hingham, Nantasket." The smaller sign points north toward "Washington Street, Quincy, Boston." Located a short distance down the road from First Congregational Church, the First Christian Science Church (below) occupied the second floor of this building at the corner of Elm and Railroad Streets. Referred to as Long's Block, this building was also home to the post office.

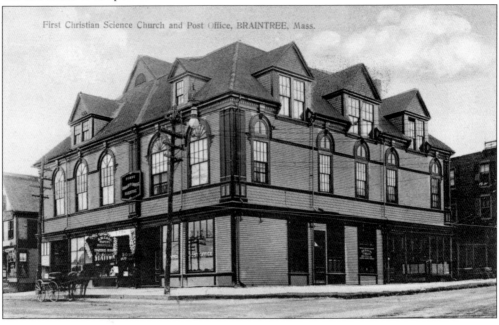

First Christian Science Church and Post Office, BRAINTREE, Mass.

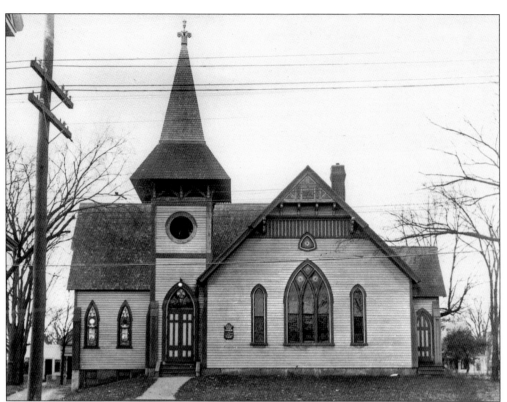

The First Methodist Church was established in 1874 in South Braintree Square. When the first church building was destroyed by fire in 1883, it was replaced with this one. The Methodists built a new, larger facility on Grove Street in 1959. The structure in this picture is now home to the Knights of Columbus. The Methodist Society of East Braintree sold its property to the Puritan Club when the two Methodist Churches merged in 1971. The Heritage United Methodist Church remains at Grove Street.

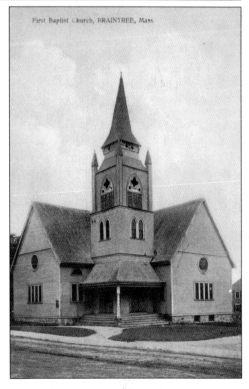

First Baptist Church, BRAINTREE, Mass.

The First Baptist Church of Braintree was built at the corner of Washington and Sampson Streets. The old church, seen here, was similar in style to the Methodist church built down the street in South Braintree Square. This structure was replaced by a modern facility in 1964.

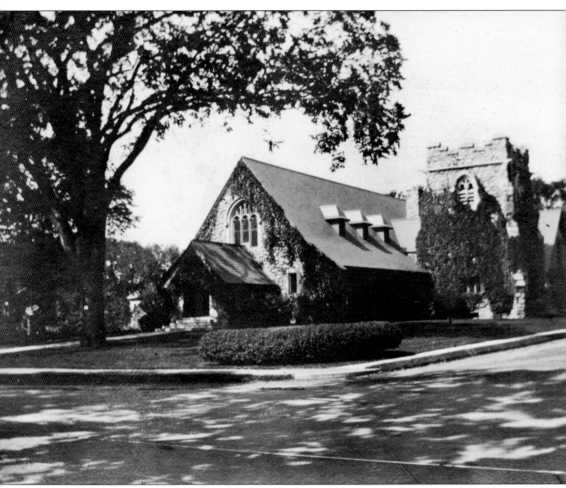

The All Souls Church, located on Elm Street between Charles and Church Streets, was built by the Unitarian Society, a liberal-leaning congregation whose goal was to create a church "where people, without regard to class, creed or color might come together on Sunday morning to listen to good music and an interesting and instructive talk on religious subjects." This beautiful stone structure was built on land donated by George Wales in 1905. The picture appears to have been taken a decade later and was found in the book *Braintree, Massachusetts: It's History*. The All Souls Men's Club, a nonsectarian club, met in the church because of its proximity to the nearby railroad station.

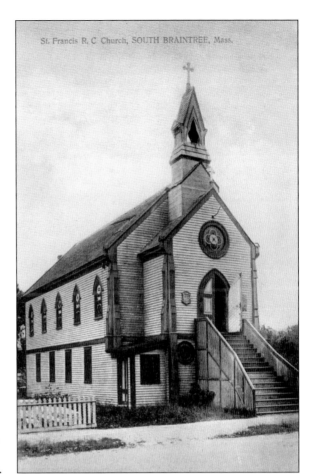

St. Francis R. C. Church, SOUTH BRAINTREE, Mass.

In 1879, Fr. Francis' Mission (right), later called St. Francis of Assisi Church, was dedicated by Archbishop Williams. It was located on the southern side of Central Avenue. This church was later converted into a private home when a new St. Francis of Assisi Church (below) was built on Washington Street in South Braintree Square in 1911. The new Spanish mission–style structure could better serve the growing Catholic population in town.

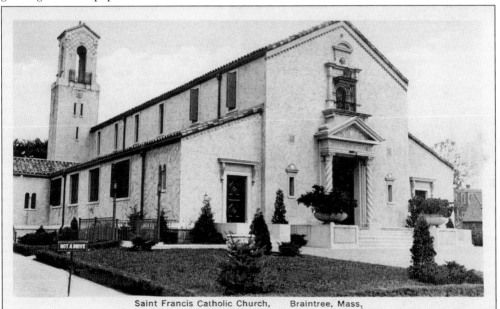

Saint Francis Catholic Church, Braintree, Mass.

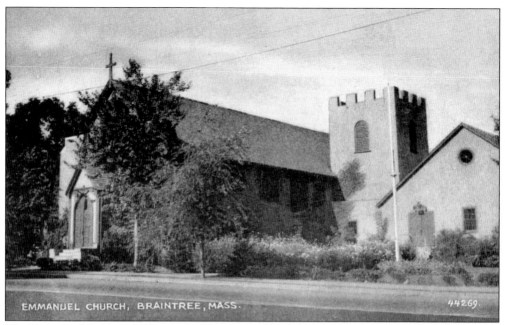

EMMANUEL CHURCH, BRAINTREE, MASS. 44269.

The Emmanuel Episcopal Church, which is located at the north corner of Washington and West Streets across from the old high school, was dedicated in 1924. The parish house and tower were added between 1936 and 1940. Beginning in 1946, the church sponsored Braintree Boy Scout Troop No. 55 for 35 years.

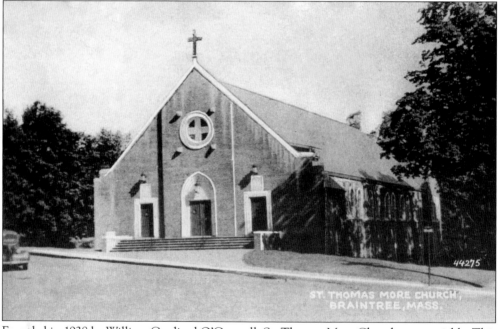

ST. THOMAS MORE CHURCH, BRAINTREE, MASS. 44275

Founded in 1938 by William Cardinal O'Connell, St. Thomas More Church grew quickly. This picture of the church was taken shortly after it was dedicated in 1940. Located at the corner of Elm Street and Hawthorn Road opposite the former site of Morrison's Mills, it was built to help serve the growing number of Catholic residents in Braintree.

Five

AT SCHOOL AND AT PLAY

Built in 1845, this impressive Greek Revival structure was originally the home of the Hollis Institute. Built with funds bequeathed to the South Parish (South Congregational Church) by John Ruggles Hollis, it originally served "children belonging and residing in said Parish." One of the original 14 board of advisors was John Quincy Adams. The school closed in 1860 when the original South Congregational Church was destroyed by fire. It is currently a private residence.

Like other schoolhouses built in the early 19th century, the South District School was a one-room structure. It stood on the west side of Washington Street just south of the original site of Gen. Sylvanus Thayer's birthplace (currently home to the Thayer Academy soccer fields). It was closed when the Highlands School opened. This structure was later moved farther south across Washington Street and was converted into a private home.

The old Southwest District School is pictured here in the 1980s. Located on Liberty Street, it served the children of South Braintree for more than two decades and was closed in 1870 when the Pond School was built. The Pond School consolidated the old West, Southwest, and Pond District Schools. This structure has been a private residence for well over 100 years.

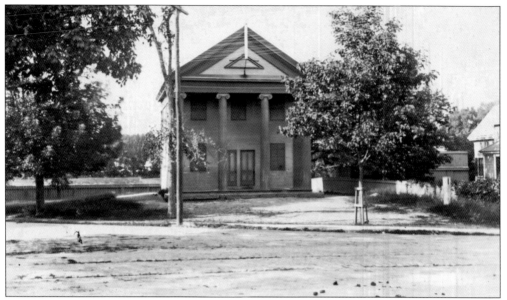

The East District School in East Braintree stood at the corner of Commercial and Shaw Streets. Built by Caleb Stetson in 1845, the academy operated as a semiprivate school for the first nine years of its existence. This picture was taken in 1890.

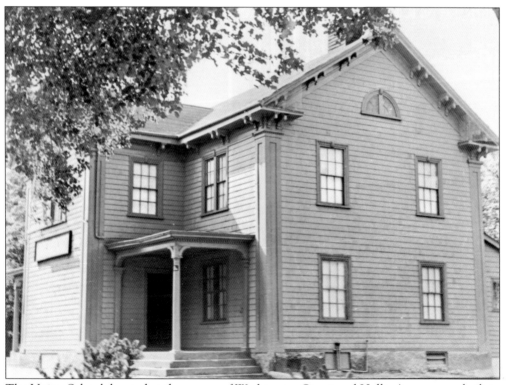

The Union School, located at the corner of Washington Street and Hollis Avenue, was built in 1869. It replaced the Old North District and Center District Schools. It has been the home of American Legion Post No. 86 for more than 70 years.

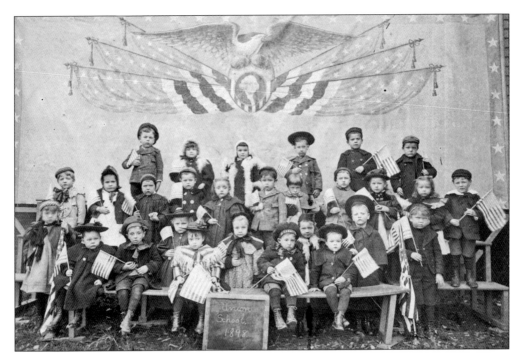

These young students (above) proudly display their American flags at the Union School in 1898. Given the traditions of the time, it is likely they were celebrating Decoration Day not the Fourth of July. Their heavy clothing further suggests that it was not July. Then again, it is possible that American flags were simply a custom at the Union School. Below, with the girls wearing their hats and the boys leaving theirs hung up inside the back door, these young students pose outside the Pond School in 1886.

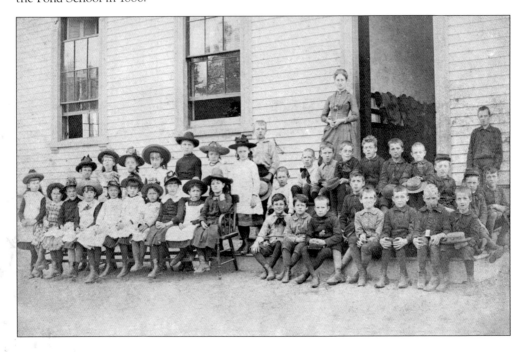

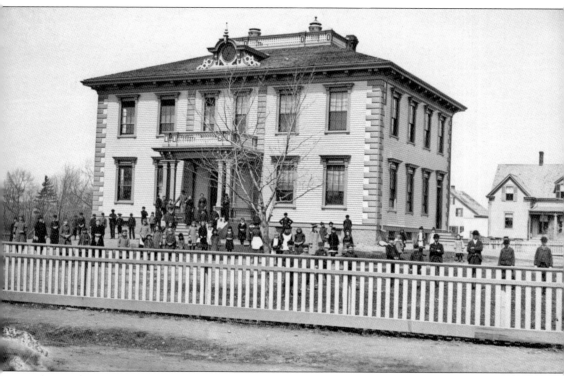

The Pond School, which opened in 1871, was located on the northern corner of Washington and Franklin Streets, facing what is now the Braintree Cooperative Bank. It was built to consolidate three of the old one-room district schools and was closed by the school department in 1942 (during World War II) to cut back on fuel expenses. The central fire station was located behind the building on Franklin Street. A bank currently occupies this site, and the house in the rear still stands on Tremont Street.

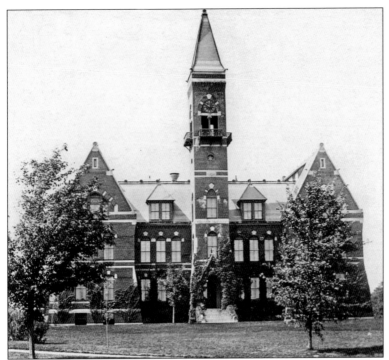

Thayer Academy opened in September 1877 with 30 students. It was built with funds donated by Gen. Sylvanus Thayer, the "Father of West Point." In his will, Thayer called for the "erection of an academy" to "promote the cause of education in the Commonwealth," and "town of Braintree, the place of my birth." This photograph was taken within 10 years after the building's construction.

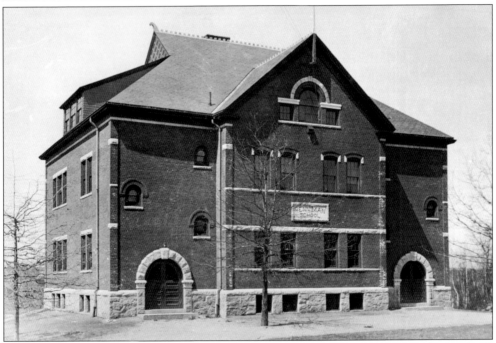

The Penniman School, located on Cleveland Avenue, was opened in 1900. It was the first brick schoolhouse in Braintree and was named after the Penniman family. This picture was taken before the additions were built. The school remained open until 1979. After the main building was demolished, a park was built in its place. The Penniman School Annex was retained and is now the home of the Braintree Council on Aging.

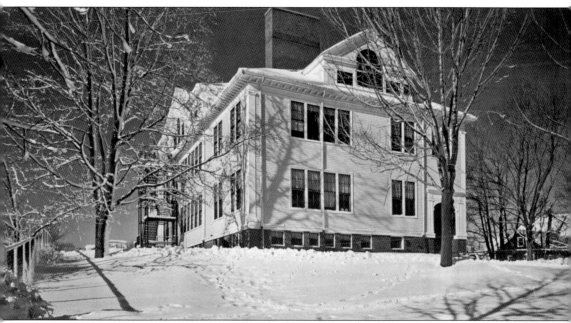

The Monatiquot School, built in 1892 on Washington Street, was located high on the hill between Academy Street and Weston Avenue. After the high school (town hall) was destroyed by fire in 1911, students were moved to the Monatiquot School, where they remained until a new facility was built in 1927. This structure was torn down in 1962.

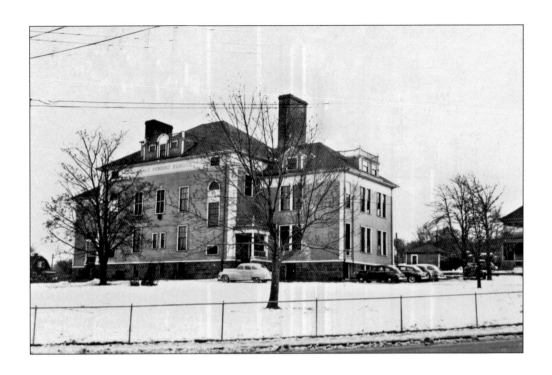

The Jonas Perkins School, pictured above in 1947, was located at the corner of Union and Liberty Streets. Built in 1894, it was named after the legendary pastor of the Union Church in East Braintree. His parsonage previously occupied this site. The picture below captures a unique winter view of the Jonas Perkins School. It was likely taken around 1910. The Monatiquot River, located at the foot of the hill behind the two houses, is just out of sight.

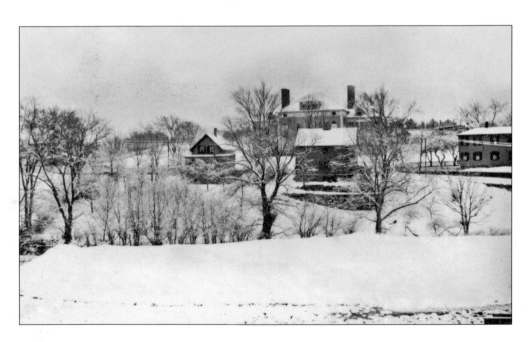

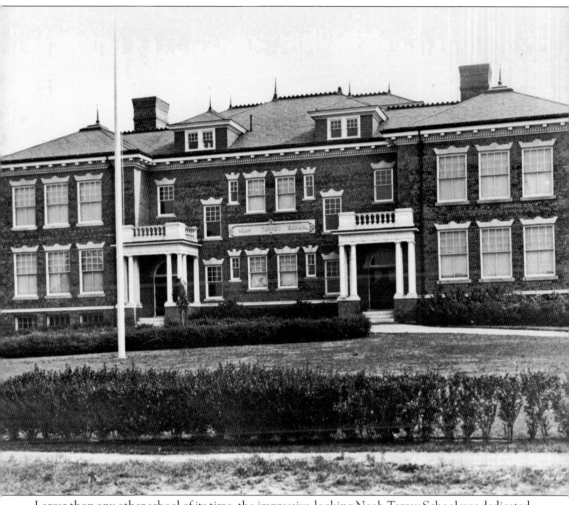

Larger than any other school of its time, the impressive-looking Noah Torrey School was dedicated in 1905. Located on Pond Street, it had (and still has) a beautiful view of Sunset Lake. It was named after a much-loved physician and longtime school committee member. After the school was closed in the 1980s, the building was leased for a time to the John Hancock Company. It now houses several town offices.

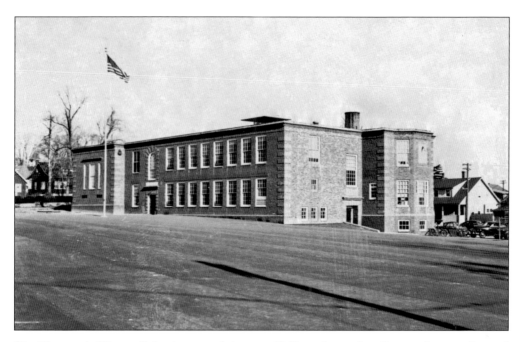

The Thomas A. Watson School, pictured above in 1947, was located on Quincy Avenue. Opened in January 1924 to serve the children of East Braintree, this school was named after the man who founded the Fore River Engine Company, the Braintree Electric Light Department, and who was an active member of the school committee. Watson also personally financed the first kindergarten program in Braintree. Although the building is still there, it now houses private businesses. The Highlands School (below) opened in September 1930. Located on Wildwood Avenue, it continues to serve the children of South Braintree.

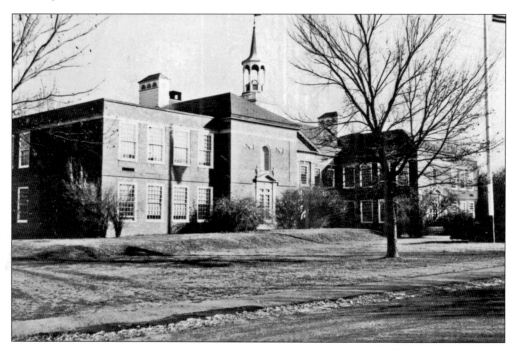

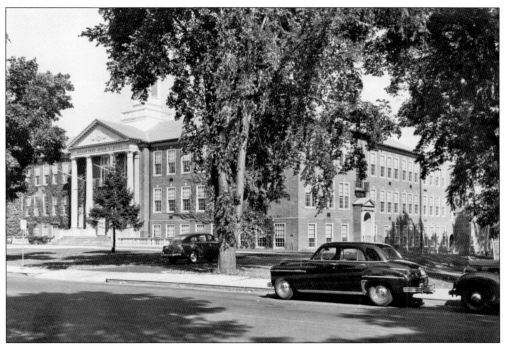

After spending several years in the cramped Monatiquot School, Braintree's high school students moved to this modern and spacious facility on Washington Street, which opened in 1927. This building served as Braintree High School for 45 years. After the new high school on Town Street was opened in 1972, this building served as Central Junior High School for several years. It was later sold to a local developer, who converted the building into condominiums.

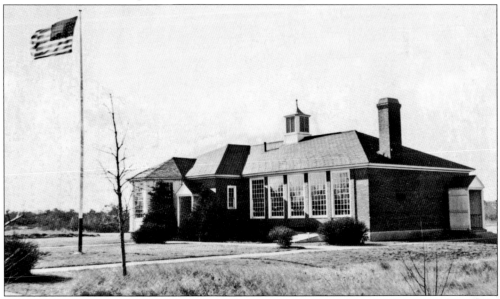

The Josephine B. Colbert School, located on Pond Street, opened in April 1938, replacing the Southwest School. It was named after a dedicated Braintree schoolteacher who taught in that neighborhood for many years. The building now houses the school department's administrative offices. This picture was taken in 1947.

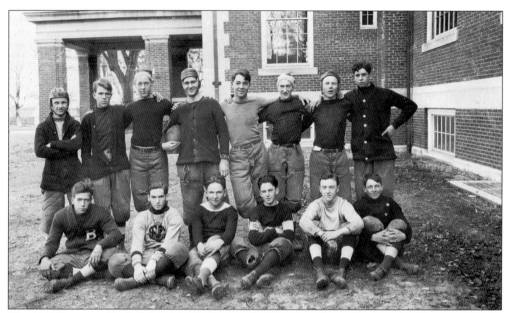

The 1914 Braintree High School football team poses next to the recently built town hall (above). Identified by last name only with their position(s) in parentheses, from left to right are (first row) Woodsum (RHB, T), Carmichael (LHB, T), Dyer (C), Hennessey (HB, QB), Dalton (LE), and Wood (sub, end); (second row) Thayer (RE), Fisher (LHB), Smith (LG), Partridge (FB, T, captain), Barlow (G, FB), Whitmarsh (QB), Mallon, (RG), and Maloney (sub, end). Their coach (and a faculty member), a Mr. Goodrich, was not photographed. Baseball, however, was historically Braintree's sport of choice. Weather permitting, there was always a baseball game being played on French's Common next to town hall. The picture below of the Braintree High School baseball team was taken behind the town hall around 1916. Central Avenue can be seen in the background.

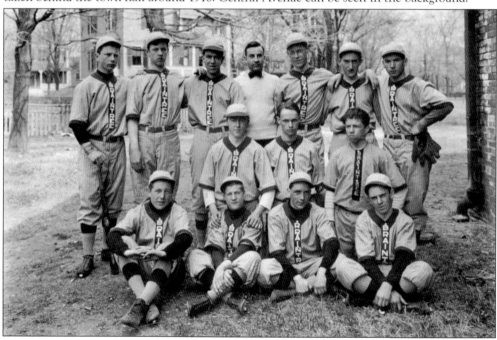

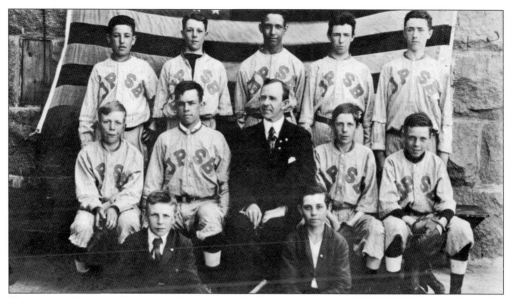

Younger students in Braintree also participated in sports. Every school, for example, had its own baseball team. The eighth-grade town champs for 1920 were the boys of the Jonas Perkins School. Seen here with their proud coach, assistant principal F. B. Taylor, the players pose outside their school.

The most popular (non-school) baseball team was the Braintree White Sox. The 1927 White Sox team was a legendary group. From left to right are (first row) George Gallivan, Herb Boardman, Stan Sylvester, Abbie Hedlund, and Leon Barton; (second row) Stan Wheeler and Ed Kjellander; (third row) Oakey Boardman, Dean Walker, John Riley, John Wentworth, John Howland, and Peter Bregoli. The photograph was taken at Hollis Field.

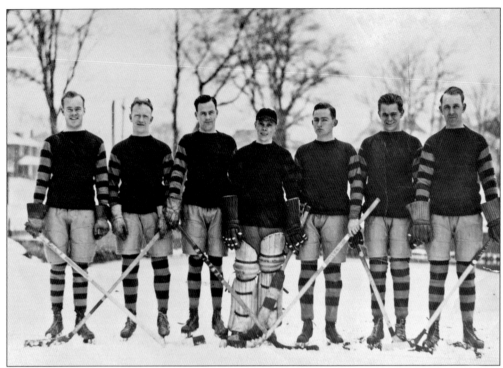

Ice hockey also became a popular sport in Braintree in the late 1920s. Braintree Hockey Club members built an artificial pond in front of the pumping station at Sunset Lake in 1930. Lights were installed by the Braintree Light Company, and money was even appropriated by the town for the project. Pictured above, members of the 1930 Braintree Hockey Club proudly pose on the rink. From left to right are Rip Keating, Bill Young, Herb Boardman, Carl Vogel, Bob Sullivan, Bill Butterworth, and Ted Young. A better view of the rink can be seen in the picture below. From left to right are Bill Young, Herb Boardman, and Wally Strathdee.

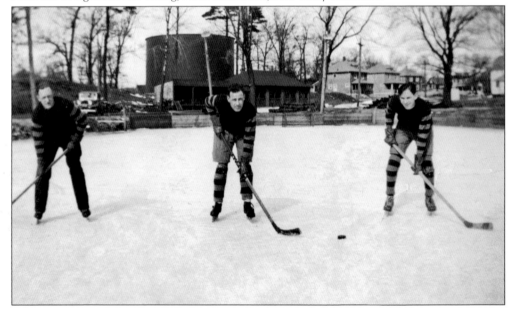

Six

BRAINTREE
GOES TO WORK

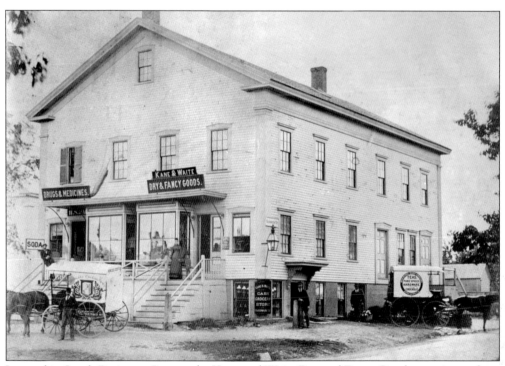

Located in South Braintree Square, the Kane and Waite Dry and Fancy Goods store is seen here on a busy day in the 1880s. The delivery wagon on the north side of the building advertises, 'Teas, Pure Spices, Hardware and Crockery.' Although it has undergone some extensive renovations, including the removal of the front stairs, this building still stands at the corner of Washington and Summer Streets across from St. Francis of Assisi Church.

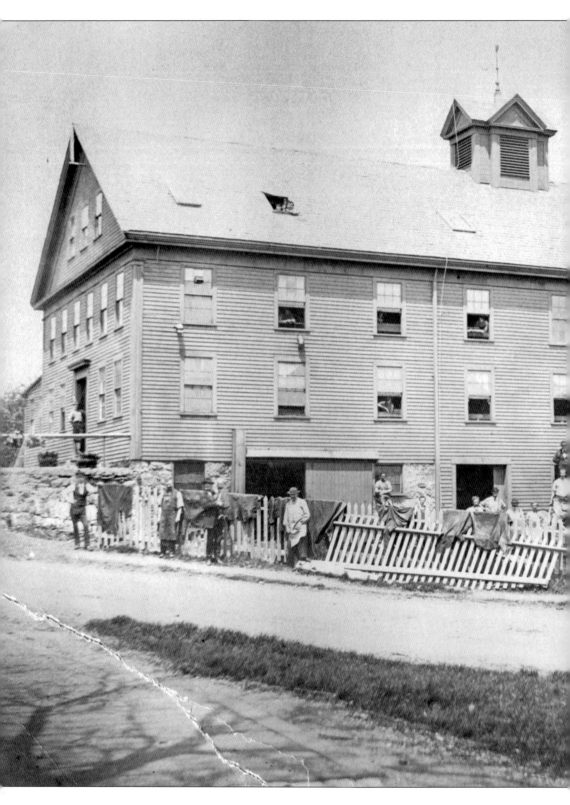

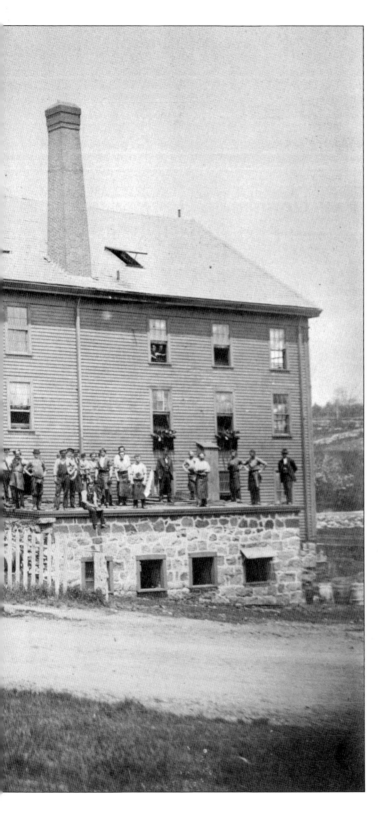

The Drinkwater Tannery was located at the intersection of Elm and Adams Streets. This structure was originally a large commercial barn built by Benjamin Vinton French. Albion Drinkwater began tanning leather in this building in 1868 using Monatiquot River water as part of the tanning process. This picture was taken on the Adams Street side of the building in the 1890s. A Mobil gasoline station now occupies the site.

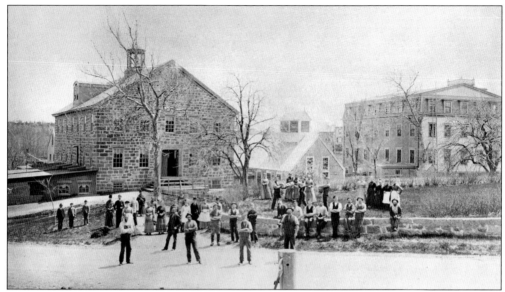

Morrison's Mills, a large and successful textile operation, was founded by Alva Morrison in 1831. It was located on Elm Street between Middle and Adams Streets. The original building can be seen on the left, and the wooden structure to the right was added in 1860. The waterwheel, powered by the Monatiquot River, was in the lower center building. The wooden building was destroyed by fire around 1920, while the stone structure remained for several more decades. This picture was taken at the beginning of Adams Street next to the Drinkwater Tannery.

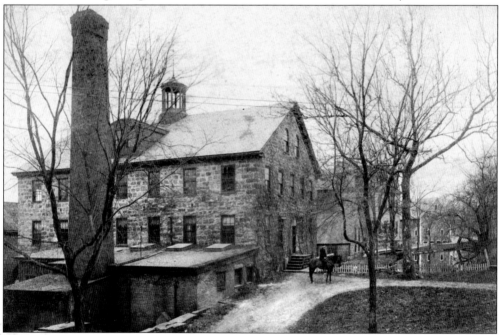

This view of Morrison's Mills was taken from the eastern side of Adams Street. After Alva Morrison retired, his three sons, Elmer, Alva, and Ibrahim, operated the business until 1899. Although the man on horseback could have been one of the Morrison brothers, he has not been positively identified.

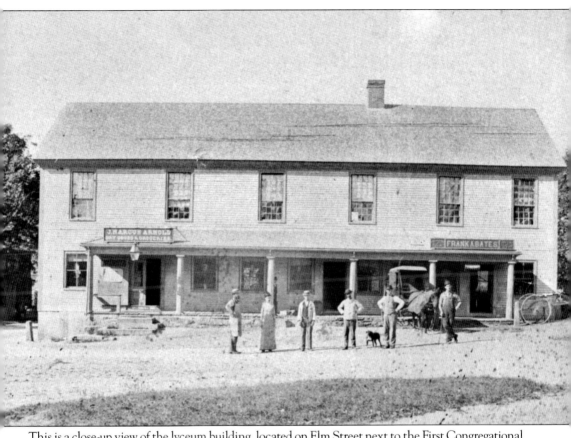

This is a close-up view of the lyceum building, located on Elm Street next to the First Congregational Church. While a large hall for public and private events occupied the second floor, two businesses occupied the first floor. Marcus Arnold's Dry Goods and Grocery store was located on the left, and Frank Bates's hardware store operated next door. Arnold is believed to be the man standing third from the left. Annie Hale is second from the left. Frank Bates is standing second from right next to his son on the far right. This picture was taken in the late 1890s.

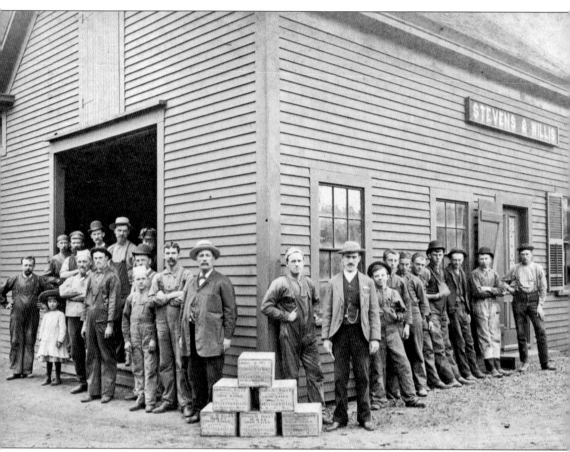

The Stevens and Willis Tack Factory was located on Pearl Street. The owners of the business are the two men with watch chains in their vests. James Stevens, a Civil War veteran and active member of GAR Post 87 is standing just left of center. George D. Willis stands second from right of center. The man in between the two partners is George Stevens, son of James. Stevens and Willis started their business at the corner Tremont and Taylor Streets and later built a factory on Pearl Street near the Ames Shovel Factory. This picture was taken at the Pearl Street factory.

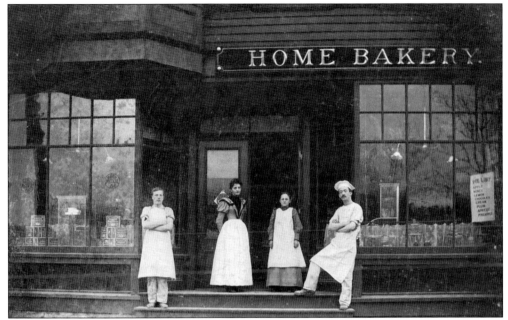

Members of the Schraut family proudly pose in front of their home bakery around 1900. According to the sign on the right, customers had quite a choice of pie flavors, including "Apple, Mince, Lemon, Chocolate, Cream, Plum, Apricot, Pineapple." This building was located on Elm Street, just west of the railroad crossing near the First Church Cemetery.

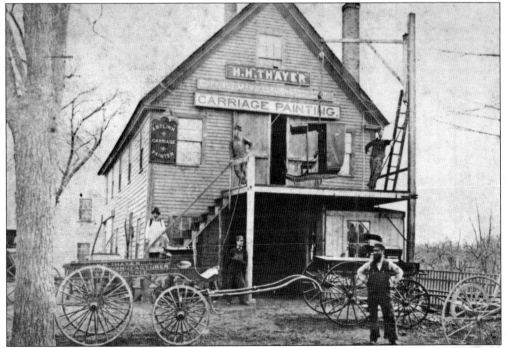

The H. H. Thayer carriage painting shop occupied the second floor of this building on Franklin Street opposite Sunset Lake, where a service station now stands. Thayer had a blacksmith shop on the first floor, where he was known to have built fire engines for the town.

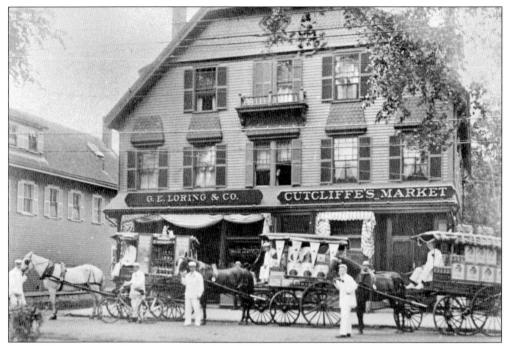

The G. E. Loring and Company and Cutcliffe's Market was located on the western side of Washington Street in Braintree Square near Storrs Avenue. Both this building and the building to the left are still standing. In 1930, this building was purchased by the Parson sisters. They lived on the upper floors, had a large garden behind the building, and owned the land extending to what is now the Archbishop Williams High School football field.

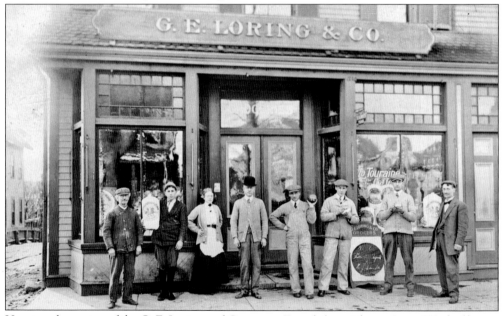

Here is a closer view of the G. E. Loring and Company. From left to right are James Weeks (former owner), Sam McCellan, Edith Clark, George Loring (owner), Sidney Hopper, Bill Drinkwater, Herbert Cranford, and Arthur Cass. This picture was taken in 1910.

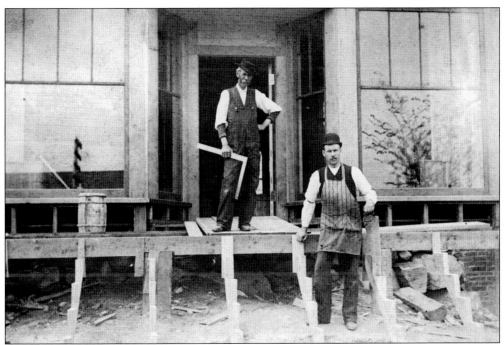

Frank Bates and his son constructed their new hardware store (above) on Railroad Avenue across from the train station. Their previous shop was located in the lyceum building on Elm Street, which was destroyed by fire in 1911. The photograph to the right confirms that father and son finished work on the stairs. Frank Bates is seen relaxing on the front porch of his hardware store. Railroad Avenue ran between his store and the wood railing fence seen in the foreground.

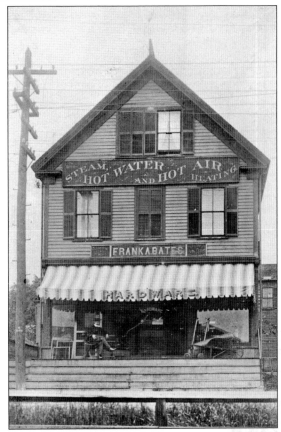

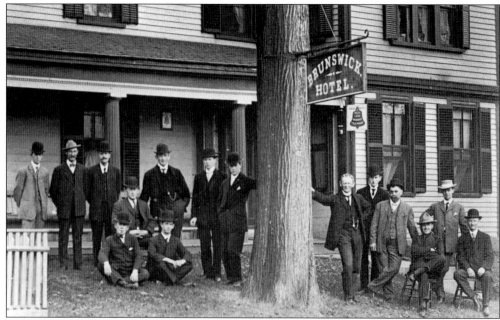

Two hotels dominated South Braintree Square at the beginning of the 20th century. The Brunswick Hotel was located on Pearl Street directly behind the Tracey building. William Sumner Tracey, who purchased the hotel in 1896, can be seen in the above photograph standing beneath the sign, the only man not wearing a hat. The picture was taken between 1900 and 1905. The hotel occupied the ground on which a McDonald's restaurant now sits. The largest hotel in Braintree for many years was the Hampton House, located on Railroad Avenue (now French Avenue) across the street from the South Braintree railroad station. The Hampton House, which played a central role in the case against Nicola Sacco and Bartolomeo Vanzetti in the 1920s, is pictured below more than a decade earlier. Campanale's Restaurant and a rear parking lot now occupy the land on which the hotel stood.

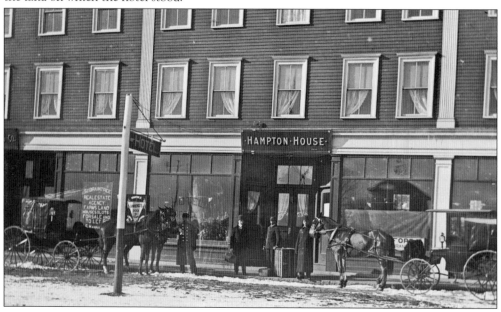

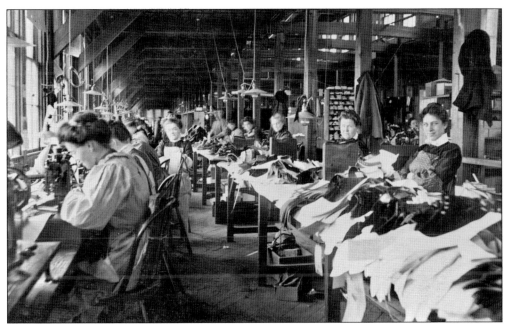

Once railroad service came to Braintree, the face of the town changed dramatically. Because workers and materials could be transported quickly and easily, several factories were built near the railroad stations. Williams Kneeland and Company built a factory near the Union Street railroad crossing in 1892. These pictures were likely taken within the next five years. As the picture above attests, a large number of women were employed in the shoe and textile industries. The men seen in the photograph below strike a relaxed pose. Bigger, and seemingly stronger, than men seen in other photographs of factory employees, these men likely operated the heavy machinery.

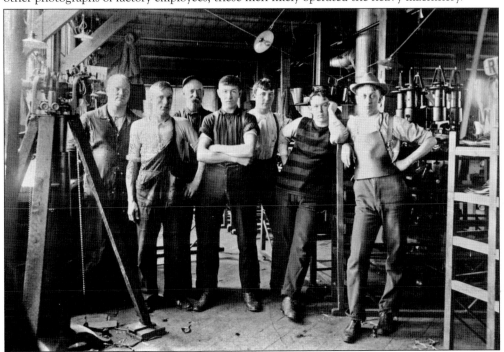

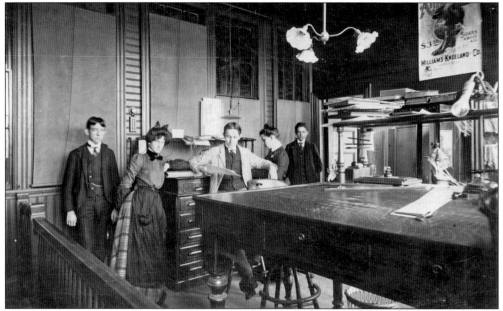

The five individuals seen in this photograph worked in the Williams Kneeland and Company administrative offices. Although the photographer identified the three men, from left to right, as Jim Cuff, John Sullivan, and Chester Daley, he neglected to identify the two women.

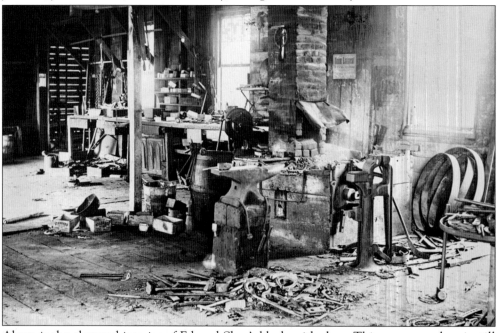

Above is the cluttered interior of Edward Shay's blacksmith shop. This one-room shop is still located at 1025 Washington Street opposite the Braintree Cooperative Bank. It was Warren Mansfield who first operated a business out of this building. Although a blacksmith, Mansfield quickly built a reputation as a fine carriage maker. He built gun carriages for the Union army during the Civil War and also constructed the first pontoon bridge for the government. He used Sunset Lake to test his design.

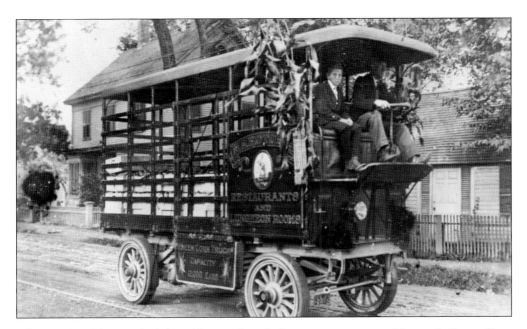

Above, a Mr. Marston (right) and his unidentified companion operate Marston's Green Corn Wagon along the streets of Braintree, making deliveries to restaurants and luncheon rooms. The sign on the truck claimed a capacity of "12,000 Ears." This picture was likely taken on Washington Street. Note the trolley tracks in the lower left corner. Below, A. W. Drollett (right) and his son proudly stand in front of Drollett's horse-pulled wagon, which advertises "Imperial Brand Teas and Coffees." According to the 1905 town directory, Drollett was also an ice dealer and superintendent of the Blue Hill Cemetery on West Street.

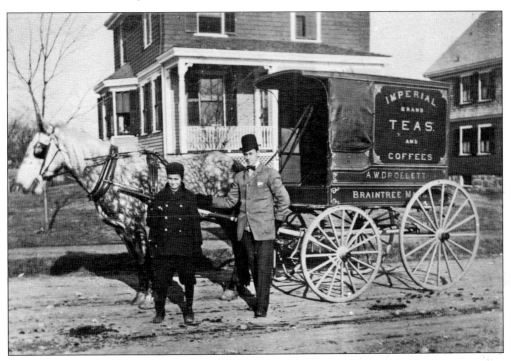

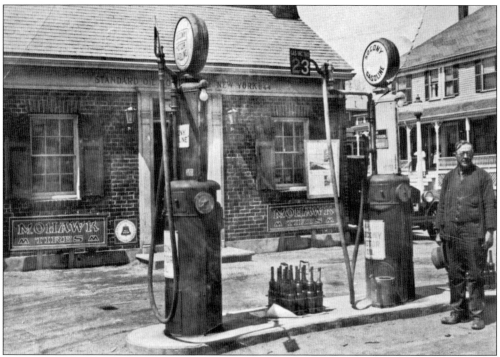

Affiliated with the Standard Oil Company of New York, this gasoline station was located at the corner of Washington and Taylor Streets. The gentleman tending the gasoline pumps in this photograph, which was taken around 1930, was "Jiggsie" Giles. A Cumberland Farms service station currently occupies this site, and the house seen in the background on Taylor Street is still there.

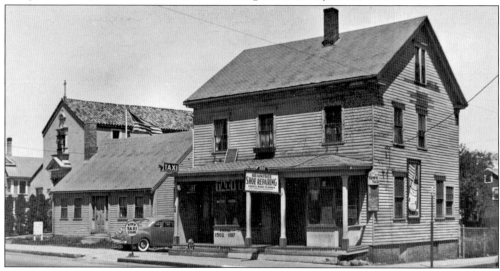

This building was located at the corner of Washington Street and Holbrook Avenue in South Braintree Square. When this picture was taken during in the late 1930s, the building was home to Simond's Taxi, owned by Harry and Hazel Simond, and Braintree Shoe Repairing, owned by Ralph Sala. When this structure was torn down, a First National store was built. It was followed in succession by Curtis Compact, Tedeschi's Food Shops, and finally a CVS Pharmacy. St. Francis of Assisi Church can be seen in the background.

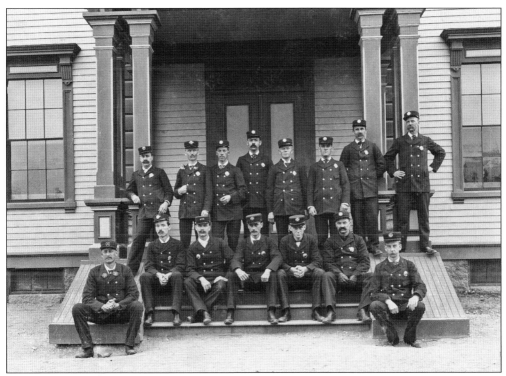

There are many photographs of Braintree town employees at work, particularly firefighters. In the 1870s, the town built three firehouses. One was built on Allen Street in East Braintree, another on Hollis Avenue behind the Union School, and a third on Franklin Street. In the picture above, 15 members of the Braintree Fire Department pose on the steps of the Pond School in 1894. The Franklin Street station was located behind the school. A bank now occupies the site of the school and fire station. In the photograph below, several firefighters pose alongside Hose No. 1 at the Allen Street Station in East Braintree. The Avery house at the intersection of Allen and Commercial Streets can be seen in the background.

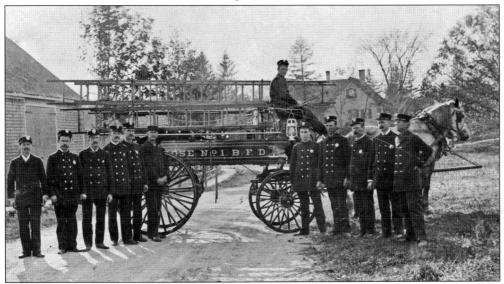

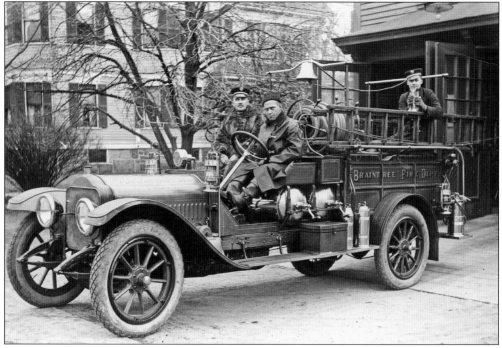

Chief Fred Tenney (wearing a fur coat) sits in the passenger seat of the combination truck in front of the firehouse on Franklin Street in 1914. Tenney served as fire chief from 1914 to 1948. Harry Sears, who later was chief from 1948 to 1964, stands on the back of the truck holding a cat. The driver is unidentified. The house in the background still stands on Franklin Street. The purpose for taking the photograph below was likely to showcase the department's motorized equipment. Sears sits behind the wheel of Hook Ladder No. 1, while Tenney operates the car. The man behind the wheel of the combination truck is unidentified.

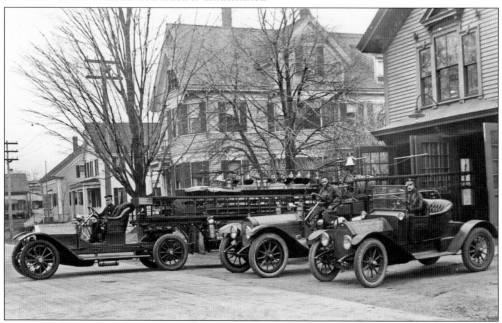

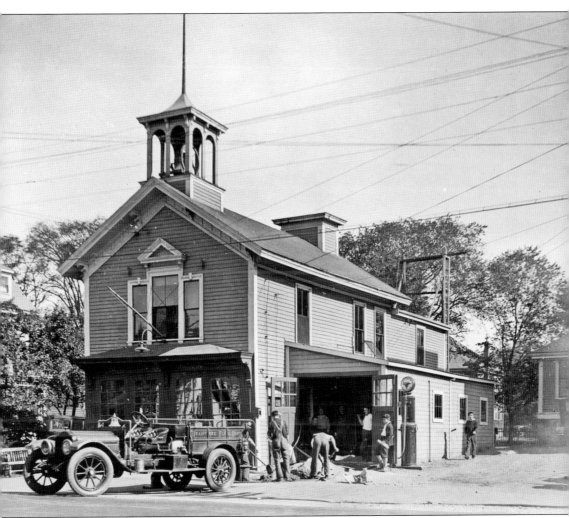

Likely taken around 1915, this image captures several Braintree firefighters at work in front of the old central firehouse on Franklin Street. The station was located behind the Pond School and faced Sunset Lake. Note the training platform and ladder located behind the station.

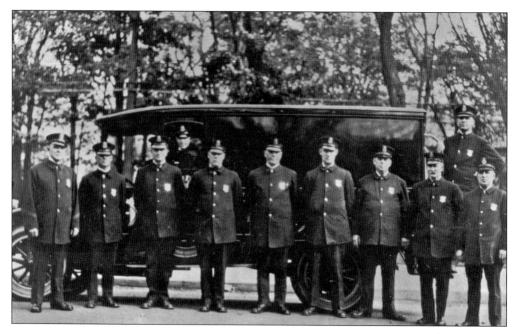

In the above photograph, taken in 1927, members of the Braintree Police Department pose in front of a new the patrol wagon. From left to right are Chief John J. Heaney, Earl A. Prario, George Novelline, Edward Cahill, Eric Nelson, Christopher Garland, Harry Annis, John P. Shay, August Johnson, Everett Buker, and Walter S. Belzia. The photograph below, taken in the early 1930s, captures the entire police department posing in front of the recently completed central police and fire station. Until the new police headquarters at the corner of Union Street and Cleveland Avenue was completed in 1976, both departments shared this building.

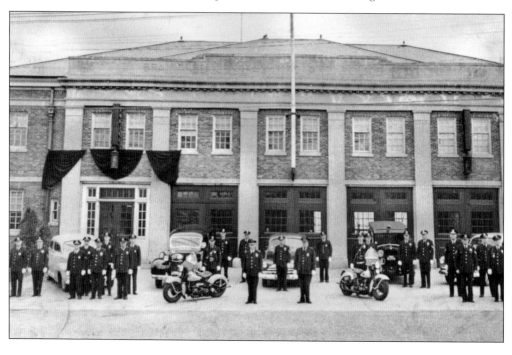

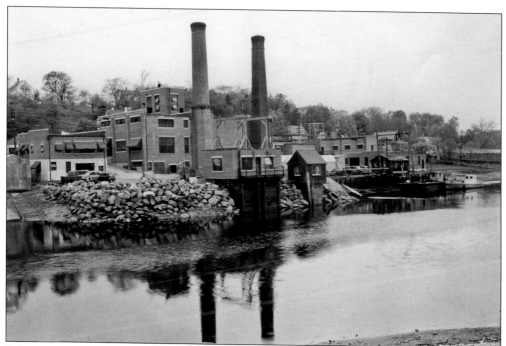

When it was finally decided to provide electric service to Braintree in 1891, town leaders elected to build their own electric power plant rather than purchase the power from someone else. Within a year, a generating plant was operating on Allen Street. The guiding force behind the project and the first manager of the Braintree Electric Light Department was Thomas Watson. The above picture of the Braintree Electric Light Department was taken in 1941. Quincy Avenue can be seen in the distance to the right. The photograph below, taken on Allen Street, captures the light department as it looked in 1921.

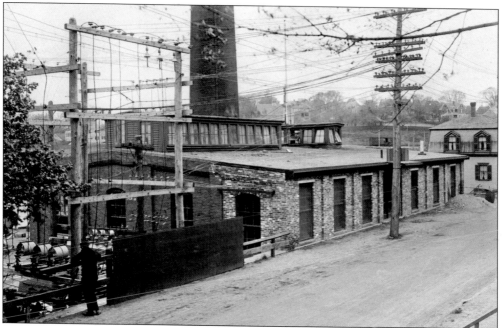

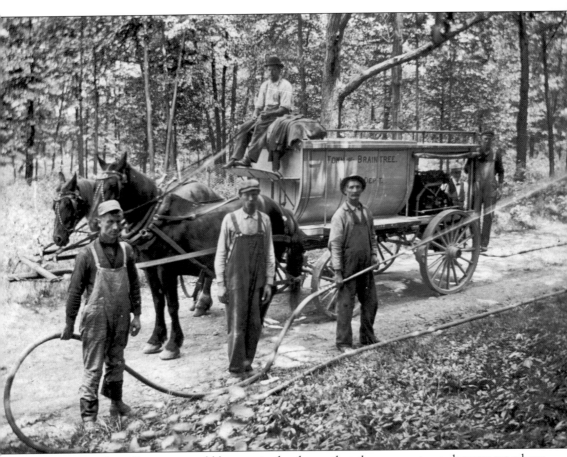

Most people in Braintree would be surprised to know that there was a town department whose sole job it was to eradicate an insect. This picture proves it. Taken in 1912, before the age of gas masks and safety suits, this image captures the five-man crew of the Braintree Moth Department busily spraying trees to rid the town of gypsy and brown tail moths.

Seven

ON THE MOVE

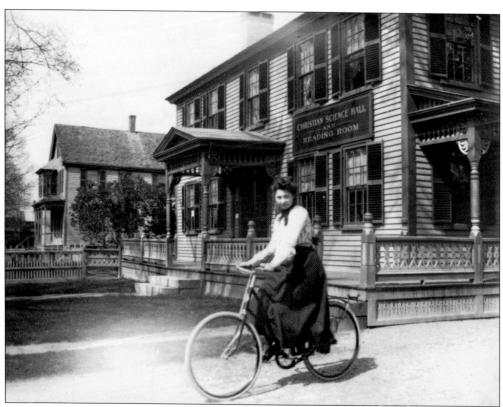

One of the more common means of conveyance in Braintree at the beginning of the 20th century was the bicycle. At a time when the streets were free of speeding vehicles, this mode of travel was easy, efficient, and healthy. In this picture, likely taken between 1910 and 1915, a young lady rides her bicycle from the Christian Science Hall and Reading Room, located at 460 Washington Street. A Hugs Plus Learning Center now occupies this building.

This picture of the crossing at Elm Street (above), looking east, was taken around 1917. Note the trolley car on the east side of the railroad tracks at the end of the line. Trolleys did not cross the tracks from either direction. The Pratt and Pratt printing office can be seen in the center of the picture. It published the *Braintree Bee*, the local newspaper that eventually became the *Braintree Observer*. The view below of the railroad crossing at Elm Street looks west toward Braintree Square, while the horse and wagon head east. An early automobile can be seen parked to the right. The large building on the western side of the tracks, known as Long's Hall, housed the First Church of Christ, as well as the post office for a short time. The entire block was called Long's Block. When the old town hall was destroyed by fire in 1912, the Braintree Town Meeting met in Long's Hall to discuss plans to rebuild. Long's Hall was destroyed by fire in the 1930s.

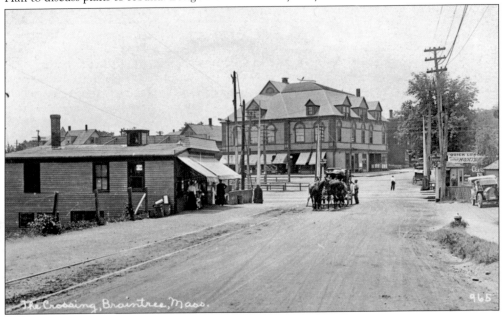

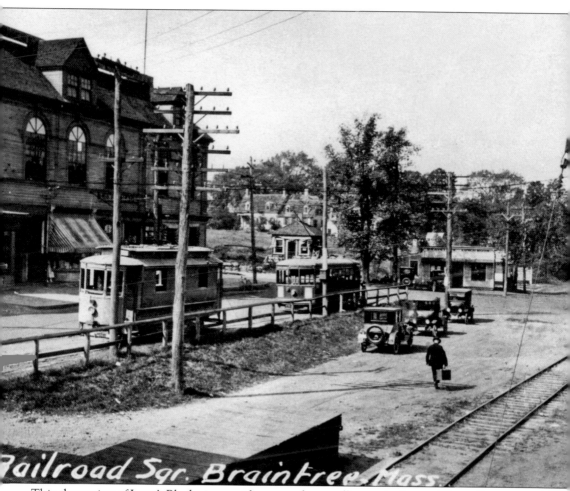

Railroad Sqr. Braintree Mass.

This closer view of Long's Block gives an idea as to where trolley service began. The trolleys were parked along Railroad Avenue parallel to the railroad tracks and then turned left onto Elm Street. Eastbound trolley service was on a separate line on the other side of the tracks. The gentleman in this picture, perhaps a salesman, appears to have just disembarked from the train. He may be walking to Braintree Square to conduct business, or perhaps he is going to the Braintree Lunch Room directly in front of him for a bite to eat. The southeast expressway now crosses directly over his head.

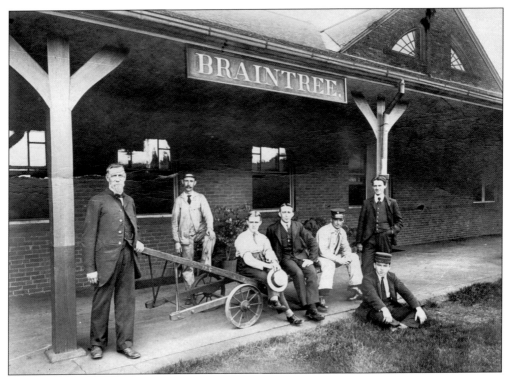

Taking a short break at the Braintree railroad station on Elm Street in August 1902 are, from left to right, T. C. Starkey (agent), Charles Jackson (bagger master), Lester Payne (freight agent), Joseph Laniere (ticket agent), Albert Hollinshead (baggage man), Harry C. Lake (telegraph operator/news agent), and an unidentifed boy sitting on the ground. The picture below was also taken at the Elm Street crossing. This view of the New York, New Haven, and Hartford Railroad at Braintree station looks south. Railroad Avenue can be seen to the far right. Note the 10¢ fare to Nantasket.

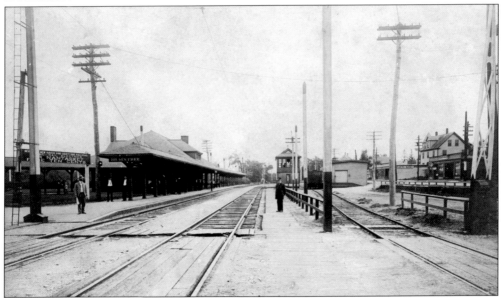

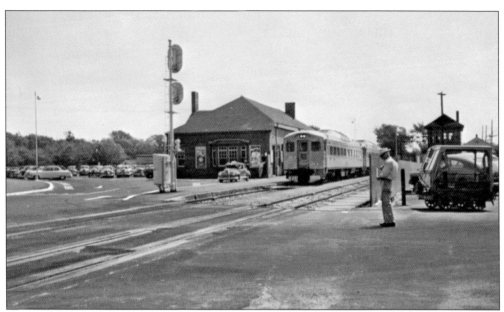

These two pictures were taken at the Braintree railroad depot on Elm Street in the early 1950s. The above picture was taken while the station was still a busy operation. Commuters parked their automobiles at the Braintree station and then took the train to Boston. A few years later, the picture below was taken from the window of a passing train at almost the same spot. It captures the demolition of the Braintree railroad station. With the arrival of expressways, one of which passed directly over this location, it was believed that passenger rail service was a thing of the past. After 114 years, the final passenger run in Braintree took place on June 30, 1959. It did not return again until 1980, when the Massachusetts Bay Transportation Authority (MBTA) arrived in town.

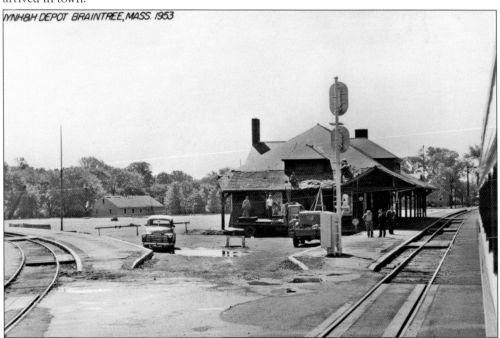

NYNH&H DEPOT BRAINTREE, MASS. 1953

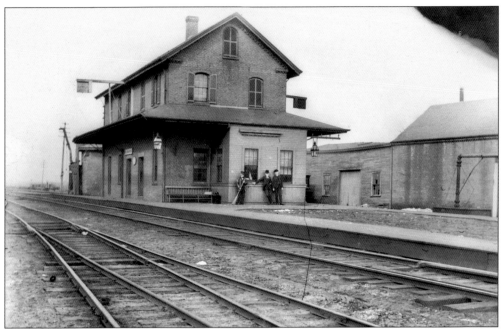

The above photograph of the South Braintree station, looking north, was taken before 1890. It was located off Railroad Avenue (now French Avenue) and was demolished in 1891. Pictured from left to right are Israel Tisdale (with a broom), James Colbert, and Briggs Wadsworth. The picture below was taken just north of the South Braintree crossing, and it captures dozens of caissons awaiting shipment during World War I. The Hampton House (the current location of Campanale's Restaurant) can be seen on the left.

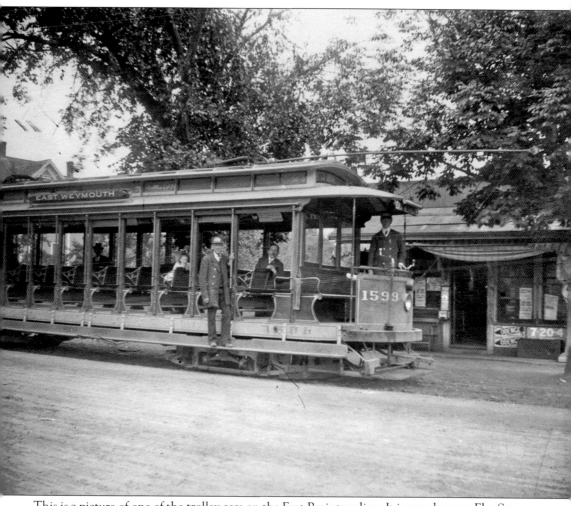

This is a picture of one of the trolley cars on the East Braintree line. It is seen here on Elm Street just east of the railroad crossing. This trolley line ended at the railroad tracks. It then headed back toward East Braintree via Elm Street, Adams Street, and Commercial Street, then into Weymouth Landing and up the hill in Weymouth to Broad Street. Next it turned left at the fire station and continued to Jackson Square and Hingham. Another trolley line was located on the other side of the Elm Street crossing and moved in the direction of Braintree Square.

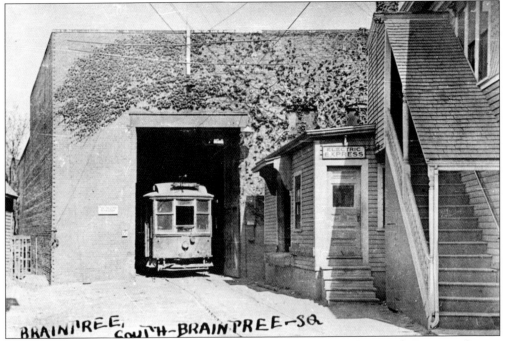

BRAINTREE, SOUTH-BRAINTREE-SQ.

The electric trolley car barn, seen above in 1917 or 1918, was located in South Braintree Square behind what is now McDonald's restaurant. The line was used for electric express, as well as freight and passenger cars. There was also bus service available to Braintree residents. The picture below was taken at the French Avenue bus stop for the South Braintree–North Easton route. The curved roof on the extreme left is the old Reclamation Plant. The house to the right is still standing on French Avenue.

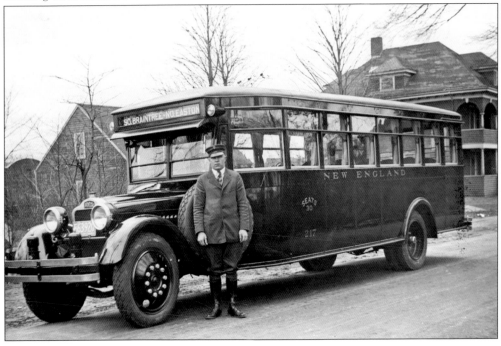

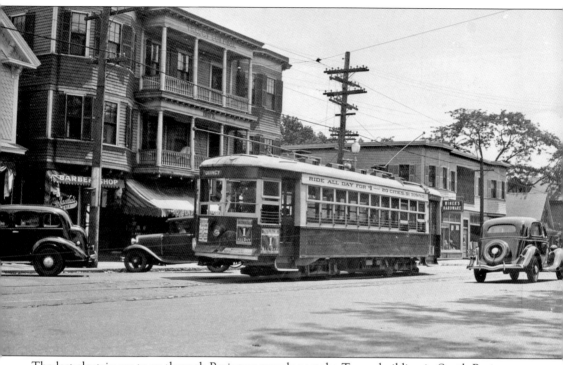

The last electric car to go through Braintree travels past the Tracey building in South Braintree Square. As automobiles became the preferred means of travel, streetcars disappeared. Pearl Street is located between the Tracey building and Winer's Hardware (seen in the distance). The Tracey building was demolished in the 1960s.

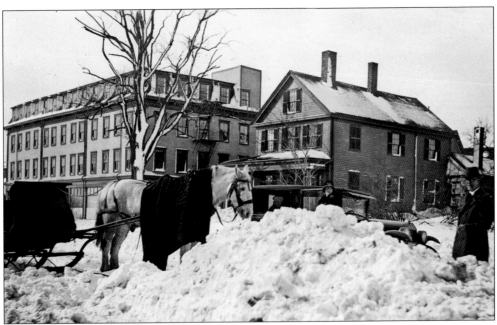

Above, Braintree residents travel on Railroad Avenue (now French Avenue) after a snowstorm in the early 1920s. While one couple traveled by automobile, the other opted for the more traditional horse-drawn sleigh. The Hampton House is the large building in the background (opposite the South Braintree railroad station). Medical doctors were often the first people in town to purchase automobiles. Braintree's own Dr. Chauncy "John" Marstin (shown below) was no exception. He is seen here behind the wheel of one of the first motorcars in Braintree, a 1904 Franklin. Marstin's house was located on the corner of Washington Street and Storrs Avenue.

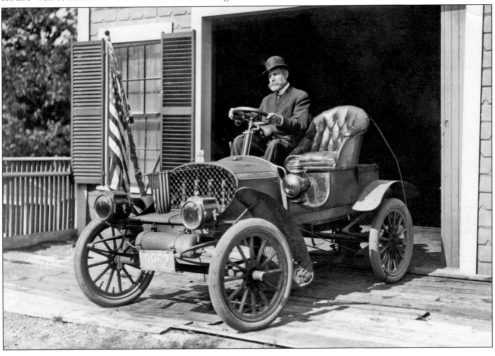

Eight

SACCO AND VANZETTI

On the afternoon of April 15, 1920, Frederick Parmenter, the paymaster for the Slater and Morrell Shoe Company, and his security guard, Alessandro Berardelli were robbed and fatally shot on Pearl Street in South Braintree. The following pictures, taken shortly after the event, depict the crime scene. This first picture was taken on Pearl Street, looking east just before the railroad crossing. Parmenter and Berardelli would have entered Pearl Street from Railroad Avenue (now French Avenue) on the left. The building in the distance to the right was their destination. (Courtesy of Boston Public Library.)

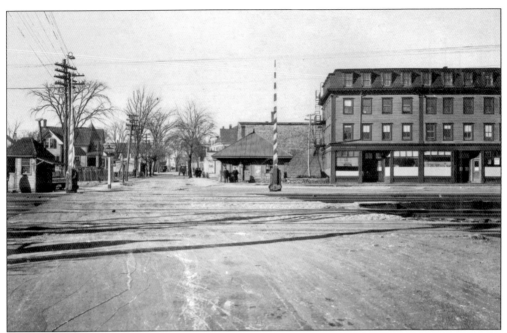

The picture above is of Pearl Street looking west toward South Braintree Square. From this angle, the Hampton House building is clearly visible. Campanale's Restaurant is now located on this corner. The house seen in the distance to the left is the only structure still standing. Frederick Parmenter, who was carrying the company payroll, and Alessandro Berardelli exited the express office, located on the first floor of this building. They walked toward the intersection and turned left onto Pearl Street, heading east. The picture below offers a view looking north down Railroad Avenue. The train station can be seen directly across the street from the Hampton House. (Both, courtesy of Massachusetts Archives.)

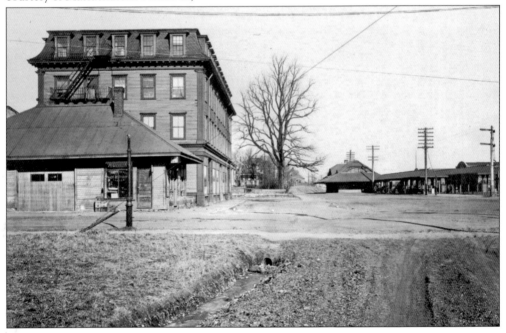

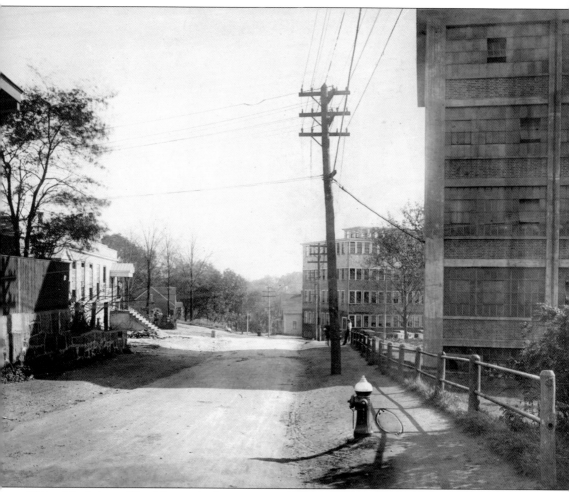

This critical view of Pearl Street, looking east, would have been the last thing seen by Parmenter and Berardelli before the shooting. As they walked down Pearl Street toward the Slater and Morrell factory (seen in the distance to the right), they noticed two men leaning against the fence in front of the Rice and Hutchins Factory (immediate right). The two men leaning against the fence in this picture are standing at approximately the same spot as the two gunmen were on April 15, 1920. One of the gunmen began to yell at Berardelli in Italian. He then pulled out a gun and shot him. Parmenter began to run across the street to the left but was pursued by the gunman and also fatally shot. The second gunman then fired at least one more shot into Berardelli, who died instantly. Parmenter managed to survive for several hours, dying early the next morning at Quincy City Hospital after telling police what he saw. (Courtesy of Boston Public Library.)

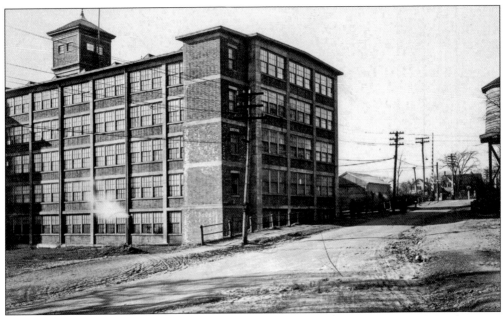

The above view of Pearl Street, looking west, gives a closer view of the spot of the shooting. Alessandro Berardelli was gunned down near the telephone pole. Frederick Parmenter was shot on the other side of the street. A third gunman may have emerged from behind a pile of bricks not far from the water tower (seen on far right). A car carrying two other men then drove up this hill, picked up the three gunmen, and sped away toward South Braintree Square. The building seen in the picture below was Parmenter and Berardelli's destination, the Slater and Morrell factory. They never made it. Two Italian immigrants and known anarchists, Nicola Sacco and Bartolomeo Vanzetti, were later arrested and charged with the murders. The case drew international attention. After a controversial trial, the men were found guilty and executed in 1927. It is widely recognized today that the two men were not afforded a fair trial. (Both, courtesy of Massachusetts Archives.)

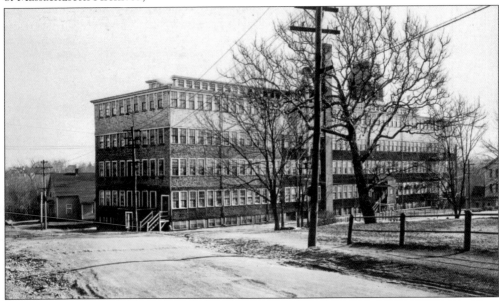

Nine

FACES OF BRAINTREE

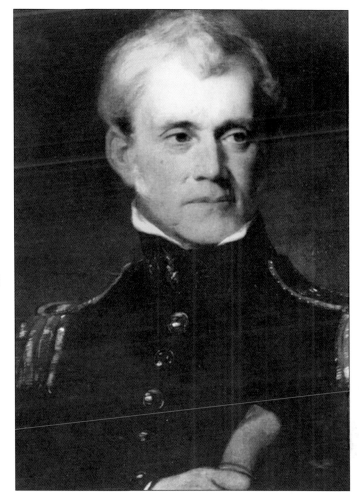

Known as the "Father of West Point," Gen. Sylvanus Thayer remains one of Braintree's most famous sons. Elected to New York University's Hall of Fame for Great Americans, Thayer has been recognized for his commitment to education, particularly in the field of engineering. Through his generosity, the School of Engineering was established at Dartmouth College. In addition, he personally financed the construction of Thayer Academy and the Thayer Public Library in Braintree. Although he achieved national fame, Thayer never forgot his hometown.

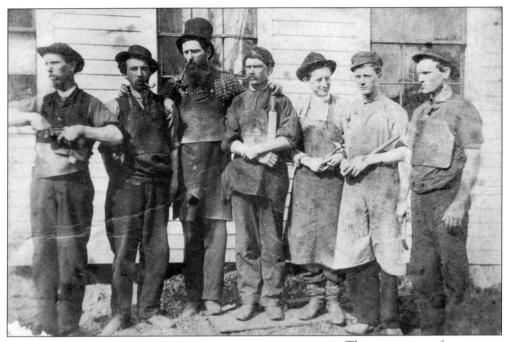

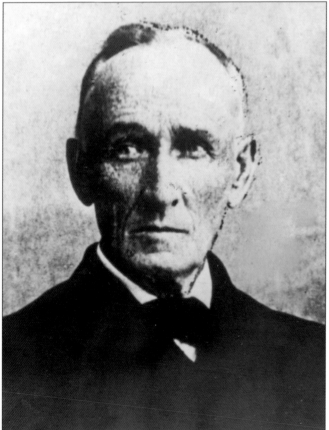

These young men from Braintree were about to enlist in the Union army in 1861 when they posed for this picture. The caption on the back of the picture reads, "On way to Quincy from Braintree to enlist as Lincoln's Minutemen. Co. C, 4th Mass Inf. Lawrence Dyer, ?, Mr. Cramm, ?, Mr. David."

Dr. Noah Torrey was an institution in Braintree for much of the second half of the 19th century. He lived at what is now 1024 Washington Street. In addition to his medical practice, Torrey served as town treasurer and town clerk, and was member of the Braintree School Committee for 22 years. The Noah Torrey School on Pond Street was named in his honor. Of Torrey, it was said, "He had a still tongue, a wise head, a soft hand, a large heart."

While Braintree has been blessed with many prominent figures, there are countless others, less prominent, who contributed to the town in their own way. This is Sally Hunt, pictured at her homestead on Hunt's Hill, which was located "east of Middle Street and north of Union Street." This house, in which Hunt was born in 1803, was far off the beaten path, "away from any street." She never married and lived alone here until her death in 1894. This picture was likely taken shortly before her death. It was said that she belonged to the "Clan of Elisha and Mary (Bowditch) Hunt."

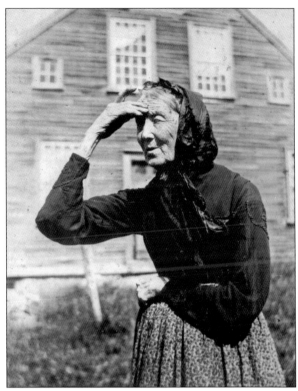

Thomas Watson lived a full life. He was a teacher, a scientist, an inventor, a mechanic, a builder, and an entrepreneur, as well as an artist and poet. After working with Alexander Graham Bell and building the first telephone, he moved to Braintree. He founded the Fore River Engine Company on the banks of the Fore River in East Braintree and spent many years building ships. His operation was later moved to the other end of Quincy Avenue and came to be known as the Fore River Shipyard. He was the driving force behind the Braintree Electric Light Department. He was also a longtime school committee member and personally financed the first kindergarten program in Braintree.

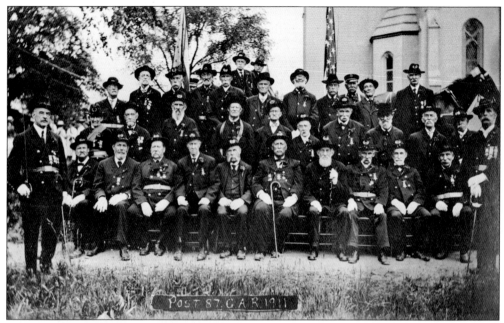

Members of Braintree's GAR Post 87 pose on the east side of First Congregational Church on Elm Street in 1911. After fighting for the Union, these men dutifully decorated the graves of their fallen comrades and oversaw the Decoration Day (Memorial Day) ceremonies in Braintree for several decades.

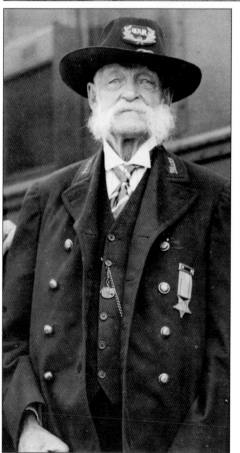

Civil War veteran and longtime commander of the Braintree GAR post, Henry Monk was a much-loved and well-recognized face in town. He served as town clerk from 1897 to 1926.

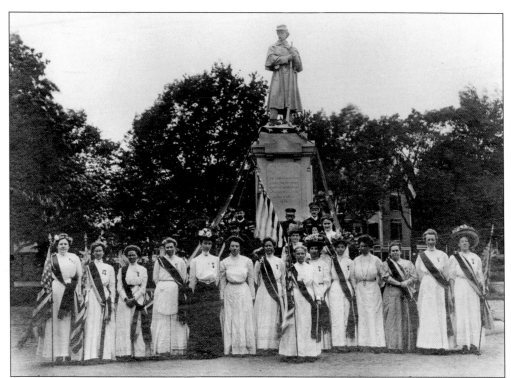

Members of the Ladies Auxiliary, Henry Monk Post of the GAR, gather in front of the Civil War monument next to town hall in the first decade of the 20th century.

Adeline T. Joyce was the first kindergarten teacher in Braintree. A graduate of Wheelock College, Joyce was hired by Thomas Watson to teach the neighborhood children of East Braintree. He also provided the space for the classroom on his property.

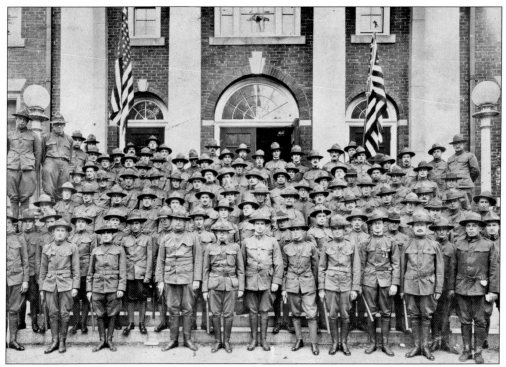

In the above photograph, the Braintree Home Guard is seen gathered on the steps of Braintree Town Hall in 1917. In the photograph below, World War I soldiers gather near the Hampton House hotel, opposite the South Braintree railroad station on Railroad Avenue (present-day French Avenue) in 1917. Within a few months, they were all in France.

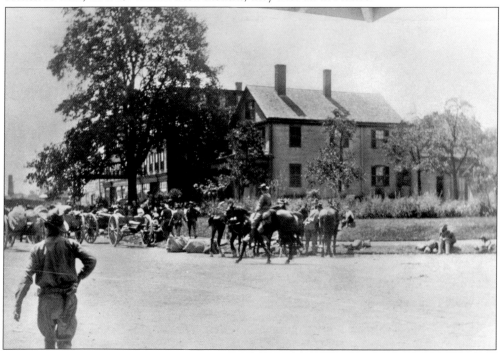

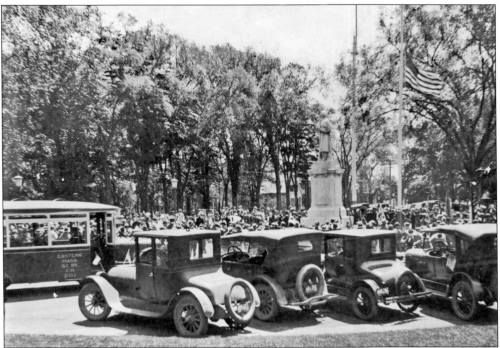

This picture captures a war bond rally at
Braintree Town Hall during World War I.

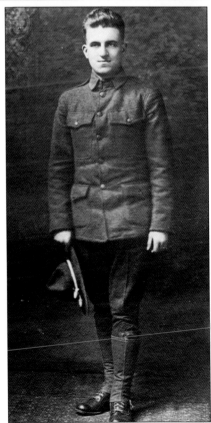

Homer Hunt, born on December 10, 1891, lived
at 19 Spruce Street. He was killed in World
War I in July 1918. His name is listed on the
veterans' memorial on the town hall mall.

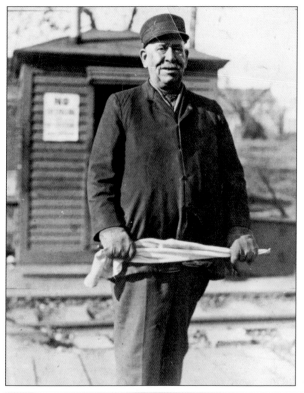

The man in the picture at left is Isaac L. Jones. He was the crossing tender at both the River Street and Elm Street crossings for nearly 40 years. He was awarded the Carnegie Medal for heroism for saving Nellie A., Edward M., and Alice Heffernan from being run over by a train in Braintree on May 13, 1912. Prior to that, on June 16, 1899, he was presented with a Bible, in which was written, "Isaac L. Jones, From the children and young people of River and Middle Sts., Braintree, Mass., to show their appreciation of his kind and thoughtful care of them at the River Street Crossing." Jones retired on Labor Day in 1922. The photograph below is of W. A. Ross, a shoemaker, standing in the doorway of his shop in South Braintree Square.

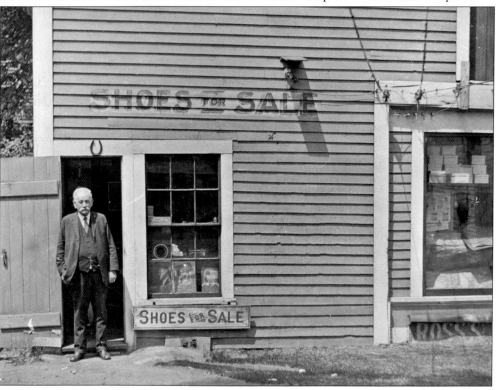

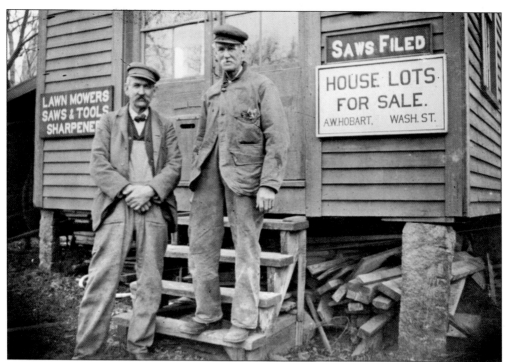

Here are two images of regular Braintree citizens going about their daily lives. The above image is of A. W. Hobart (left) and an unidentified coworker standing in front of Hobart's shop, which stood opposite Sunset Lake on the east side of Washington Street. The image at right captures Walter Ellis driving "Old Nellie" down Liberty Street in East Braintree.

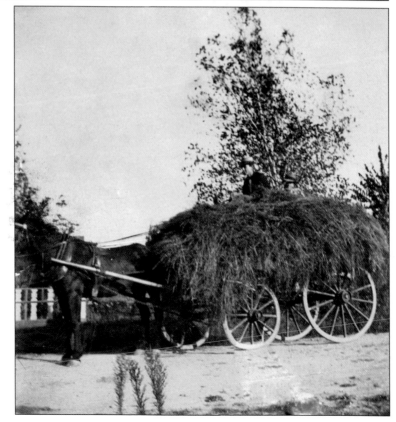

Pictured here is Congressional Medal of Honor recipient and longtime Braintree resident Charles A. MacGillivary (1917–2000). Cited for "courage far beyond the call of duty," MacGillivary saved the lives of countless American soldiers when he single-handedly charged and captured four German machine gun nests in France on New Years Day in 1945. MacGillivary was seriously wounded, losing his left arm. He was a former president of the Congressional Medal of Honor Society and was a good man. He is sorely missed.

Congressman John F. Kennedy paid a surprise visit to Charlie's Barber Shop in Weymouth Landing while campaigning for the senate against incumbent Henry Cabot Lodge Jr. The calendar on the wall suggests that election day was right around the corner in October 1952. While the customer in the chair has not been identified, the barber is Anthony DiTullio, the father of Bob DiTullio, who himself has been cutting hair in Braintree since 1962. (Courtesy of Bob DiTullio.)

Sen. John F. Kennedy returned to Braintree six years later, speaking at Braintree Town Hall in 1958 (above). From left to right are Braintree selectman Harry Smiley, James Mullen of Milton, Rep. Carl R. Johnson Jr. of Braintree, Robert Taylor of Braintree, Franklin Fryer of Weymouth, and Kennedy. Fryer has been serving as Weymouth's town clerk for 44 years. After Kennedy was assassinated five years later, Johnson was instrumental in having the street in front of town hall renamed JFK Memorial Drive. Below, State Rep. Carl R. Johnson Jr. (center) introduces Kennedy to several Braintree residents in South Braintree Square, including (from left to right) Frank Novio, Anthony Richardi, and Percy Fabiano. (Courtesy of Carl R. Johnson III.)

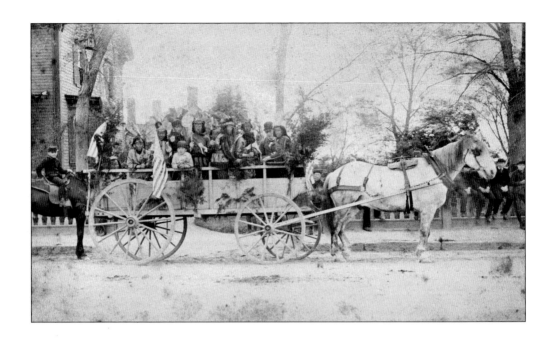

On May 22, 1890, the Town of Braintree celebrated its 250th anniversary with a 2-mile-long parade. One entry was a wagonload of schoolchildren dressed as Native Americans (above). Another view of the 1890 parade (below) captures several flag-waving Braintree residents piled into a stagecoach. This picture was taken when the coach stopped for a moment in front of the Kane and Waite Dry Goods stores at the corner of Washington and Summer Streets. This building still stands across the street from St. Francis of Assisi Church in South Braintree Square.

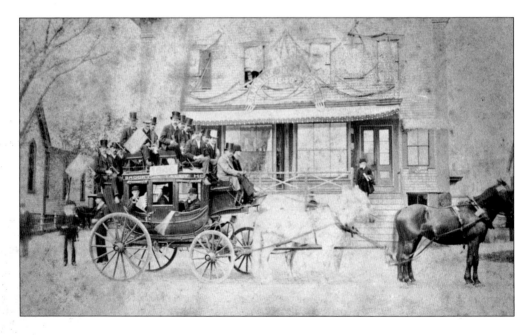

The Town of Braintree celebrated its 300th anniversary with a tercentenary parade on May 25, 1940. The above picture was taken on Washington Street in front of French's Common. Another view of the 1940 parade can be seen below. Upon close inspection, it appears that the stagecoach used in 1890 parade was used again 50 years later.

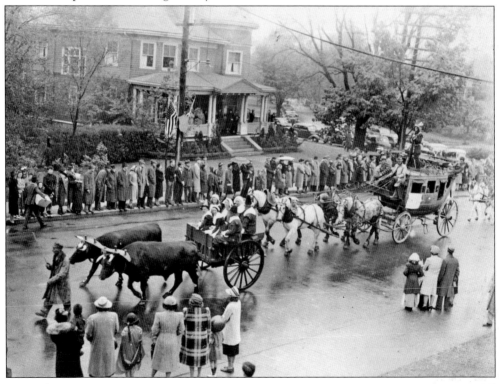

The Braintree Board of Selectmen marched in the May 1990 parade as part of the town's celebration of its 350th anniversary. From left to right are Joseph Sullivan, James Galvin, Frank Toland, and John Dennehy. The fifth member of the board, Marge Crispin, was smarter than the rest of us, opting to ride in the open convertible behind us. The woman walking next to the yellow convertible is Nancy Nicosia, co-chairperson of the 350th celebration.

Joseph C. Sullivan was sworn in as Braintree's first mayor on January 2, 2008, ushering in a new era in Braintree town government. (Courtesy of Joseph C. Sullivan.)

Braintree's first town council was sworn in by town clerk Donna Fabiano on January 2, 2008. From left to right are Dan Clifford, Ronald DeNapoli, Henry Joyce Jr., Thomas Bowes, John Mullaney, Charles Kokoros, Charles Ryan, Harold Randolph, and Leland Dingee. Dingee was elected president of the council. Mayor Joseph C. Sullivan looks on from the right. (Courtesy of Joseph C. Sullivan.)

As a gesture of respect and recognition of a connection to the past, Mayor John C. Sullivan was sworn in using a Bible that once belonged to John Quincy Adams. Several dignitaries from across the state attended the swearing in ceremony. Inspecting the Bible are, from left to right, State Rep. Joseph Driscoll, Sullivan, Kelly Cobble of the National Park Service, Sen. John F. Kerry, and Congressman Stephen Lynch. (Courtesy of Joseph C. Sullivan.)

www.arcadiapublishing.com

Discover books about the town where you grew up, the cities where your friends and families live, the town where your parents met, or even that retirement spot you've been dreaming about. Our Web site provides history lovers with exclusive deals, advanced notification about new titles, e-mail alerts of author events, and much more.

Arcadia Publishing, the leading local history publisher in the United States, is committed to making history accessible and meaningful through publishing books that celebrate and preserve the heritage of America's people and places. Consistent with our mission to preserve history on a local level, this book was printed in South Carolina on American-made paper and manufactured entirely in the United States.

This book carries the accredited Forest Stewardship Council (FSC) label and is printed on 100 percent FSC-certified paper. Products carrying the FSC label are independently certified to assure consumers that they come from forests that are managed to meet the social, economic, and ecological needs of present and future generations.

FSC
Mixed Sources
Product group from well-managed
forests and other controlled sources

Cert no. SW-COC-001530
www.fsc.org
© 1996 Forest Stewardship Council

Find Your Place in History.